ABANDONED ASYLUMS OF MASSACHUSETTS

Images of Modern America

FRONT COVER: A chair sits in the stairwell of the partially abandoned Wrentham State School, now known as the Wrentham Developmental Center. (Courtesy of Tammy Rebello and TMR Visual Arts.)

UPPER BACK COVER: Furniture is piled high for trespasser access into one of the many cottages at Belchertown State School. (Courtesy of Tammy Rebello and TMR Visual Arts.)

LOWER BACK COVER: On the left, this is the only original building remaining on the campus of the Metropolitan State Hospital site in Waltham, Massachusetts. The administration building was named after Dr. William F. McLaughlin, a flight surgeon in World War II who was once an administrator here. In the center, Belchertown State School, which is in the beginning stages of demolition, houses a piano in a recreational building. At right, once a doctor's residence, this house sits partially furnished on the campus of Paul A. Dever State School in Taunton. (All courtesy of Tammy Rebello and TMR Visual Arts.)

ABANDONED ASYLUMS OF MASSACHUSETTS

Images of Modern America

Tammy Rebello and L.F. Blanchard

ARCADIA
PUBLISHING

Published by Arcadia Publishing
Charleston, South Carolina

Printed in the United States of America

Library of Congress Control Number: 2015956693

For all general information, please contact Arcadia Publishing:
Telephone 843-853-2070
Fax 843-853-0044
E-mail sales@arcadiapublishing.com
For customer service and orders:
Toll-Free 1-888-313-2665

Visit us on the Internet at www.arcadiapublishing.com

Dedicated to all those who strive for a better tomorrow.

Tammy dedicates this book to:
Amanda, Emalee, Austin, and Errick—the loves of my life.
My brothers Tim and Josh for being my exploration buddies.
Beth for being my partner in crime.
My parents, for their unconditional love and support.
Lastly, to Gram, you are my daily inspiration
to work hard and achieve my dreams.

L.F. dedicates this book to:
Cathy, for giving me reason to breathe.
Mom and Dad, who gave me everything.
Tina, for being a light in the darkness.

CONTENTS

ACKNOWLEDGMENTS

Christine (Tina) Runyan, PhD, ABPP; Brandi Silver, BS, MS, PhD; Kat O'Connor; Andrea Martin, PhD; Jack Yates; Eli Minkoff, PhD; Doe West, MS, MDiv, PhD; Earl Storey; Don Gale; Cheryl Welcher, Westborough Historical Society; and of course, Erin Vosgien, Jeff Ruetsche, and the Arcadia staff for all of their support. Without them, this project would not have come to fruition.

Unless otherwise noted, all images are courtesy of Tammy Rebello and TMR Visual Arts.

FOREWORD

We may want to believe mental illness is no longer stigmatized and that parity in health care exists, but the reality is one of continued marginalization of resources, limited access to high-quality health care, and a society that feeds shame as a main course to those suffering. There continues to be entirely too much sorrow and grief that accompany living with mental illness, or loving someone with mental illness, due to stigma, fear, uncertainty about getting help, and inadequate resources when help is sought.

Still, I have witnessed tremendous progress, particularly in the field of integrated health care—in which mental health clinicians practice alongside primary care providers, and mental illness can be diagnosed and treated in primary care settings. The vast majority of visits to primary care providers are linked to one or more unmet behavioral health needs, such as stress, depression, anxiety, poor sleep, obesity, relationship issues, uncontrolled diabetes, or unremitting chronic pain. Having the right type of doctor, at the right place and at the right time, expands access to care, reduces augmentation, improves quality, reduces cost, and—most importantly—decreases suffering.

As a clinical psychologist working in primary care, arguably one of the front lines of health care, I am privileged to care for people alongside their family physician in a collaborative and continuous model of practice, which honors the emotional and physical ups and downs throughout a lifetime. But this model of care is not yet mainstream, and the pace of change towards integrated health care, rather than fragmented, feels glacial. There continues to be too many barriers to effective and compassionate mental health treatment, and the way in which health care is financed and appropriated in the United States is chief among them.

Health is not the absence of disease, it is a state of vitality and functioning in which mental and physical well-being are inexorably connected. But when health insurance companies deny member benefits for mental health assessment and treatment, there is no subtlety in the message that mental health is a luxury rather than a necessity for health. When each of us boldly acknowledges that the face of mental illness is not a stranger's face, but rather is our neighbor's face, our co-worker's face, our sibling or children's faces, or even your face or my face, the more we reduce stigma and shame. The more we disabuse misperceptions of mental illness as a moral failing or an excuse for violence, and actually fund social programs, health care, and meaningful treatment, the images on these pages will not only evoke disbelief and horror but also appreciation for how compassionate and accessible care can heal people *and* systems.

Tina Runyan, PhD, ABPP
Clinical Health Psychologist
Clinical Associate Professor
University of Massachusetts Medical School
Department of Family Medicine and Community Health

INTRODUCTION

The subject of mental health has been laced with negative connotations since the beginning of recorded time. As with many things, an unfamiliarity and misunderstanding of the origins of mental illness have played a heavy role in the persecution of those afflicted. From the Middle Ages to the Age of Enlightenment, Western societies attributed most mental illnesses to demonic possession. Even into the 20th century, the American public held misconceptions of the mentally ill, reacting to them with fear and horror.

Laws for the creation of first state asylum in the United States were passed in 1842 in New York. Utica State Hospital opened eight years later, due largely to the work of Dorothea Lynde Dix (April 4, 1802–July 17, 1887). Though she was born in Hampden, Maine, Dorothea spent much of her childhood in Worcester, Massachusetts, until she moved in with her wealthy grandmother in Boston. Growing up with an emotionally absent mother and an abusive father, she developed a sensitivity to the hardships suffered by others.

While teaching inmates at a local jail, she became aware of the cruelties inflicted upon the insane. She became a social activist and dedicated her life to the fight for a dignified life for the insane throughout the United States and in Europe as far east as Constantinople.

The culmination of her work was the Bill for the Benefit of the Indigent Insane: legislation that set aside 12,225,000 acres of federal land to be used for the care of the insane, blind, deaf, and dumb. Though the bill passed both houses of the United States Congress, it was later vetoed by Pres. Franklin Pierce in 1854. He argued that social welfare was the responsibility of the states. Stung by the defeat of her bill, Dix traveled to England and Europe. In 1854 and 1855, she conducted investigations of Scotland's madhouses, resulting in the formation of the Scottish Lunacy Commission to oversee reforms.

Though there have been great evolutions in the field over the past century, there remains a need for improvement. Throughout the second half of the 20th century, great leaps in the effectiveness of medications and modes of therapy proved beneficial, but even with these advances there remains a negative stigma around those who suffer from perceived mental disorders and disabilities.

Our mission with this project is not to sensationalize the abuses of the past, but to educate and enlighten. We wish to bring to light the realization that the pursuit of good mental health and those who seek and/or need help is not synonymous with weakness, but with great strength. The desire to evolve in pursuit of a better tomorrow is a noble goal, deserving of validation and respect.

One

BELCHERTOWN

STATE SCHOOL

42.2750° N, 72.4151° W

A Story of Change

On October 31, 1963, only a few weeks before Pres. John F. Kennedy was assassinated, he signed into law an act that changed the way mental health care was approached in the United States. The Community Mental Health Act, also known as the Mental Retardation and Community Mental Health Centers Construction Act of 1963, inspired new optimism in mental health care. The legislation was intended to help those with mental illnesses receive treatment on an outpatient basis while living at home and working. These options were a welcome alternative to being kept in state institutions, which often became neglectful and abusive.

When he signed the bill, President Kennedy said that the number of people living in state mental hospitals—then more than 500,000—could be cut in half. The proposed 1,500 centers would supply successful and timely treatment to patients in their own communities and then return them to "a useful place in society."

Unfortunately, President Kennedy's vision was never fully realized, as only half of the proposed centers were built; those that were constructed were sadly understaffed and underfunded. Countless patients who were in need of care were undiagnosed, undertreated, or fell back into the severely understaffed schools and hospitals. The bill left them homeless and without any of the intended help that was so drastically needed. While President Kennedy's legislation provided $329 million to build these outpatient mental health centers, it did not provide money to operate the centers long term. There was no single place in the community for people to go for mental health services, and those who had formerly been in institutions often went without any form of treatment.

For places like Belchertown, it would take another decade and a number of tragedies before they saw real change. The catalyst, in this case, was the extreme neglect and abuse of a young male patient and the determination of his family to be sure no one else had to suffer such indignities again.

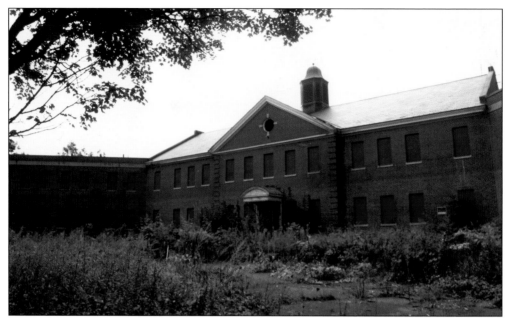

In 1916, the Massachusetts State Board of Insanity voted to purchase, by eminent domain, the land that Belchertown State School would be built on for $46,800. In 1917, though the school was not yet open, Mr. and Mrs. John Hawes, warden and matron, accompanied 10 male residents from Wrentham State School to clear the land and plant crops that were sent back when harvested.

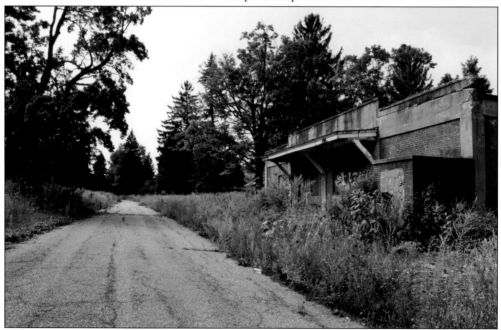

Construction began in 1919, with a dormitory and several essential buildings such as power, storehouse, laundry, and bakery. This also included 1,500 feet of concrete tunnels connecting the buildings. The Belchertown State School for the Feeble-Minded, in Belchertown, Massachusetts, opened on November 15, 1922. It was the third facility constructed in the commonwealth around that time to alleviate overcrowding at Fernald and Wrentham State Schools.

After opening, Belchertown State School accepted its first patients: 65 boys who transferred from Fernald. Later that same month, 128 more came from Fernald and Wrentham. One year later, the population had risen to 428, and by 1926 it was well over capacity at 743. The merry-go-round must have been popular.

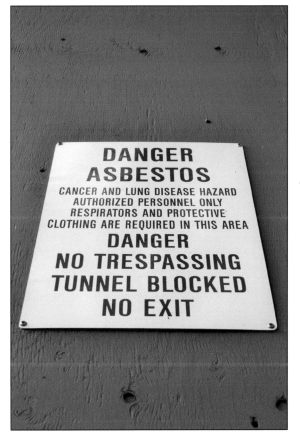

The Belchertown State School for the Feeble-Minded was built in western Massachusetts. The 876-acre campus was comprised of 10 major buildings, constructed in Neocolonial architectural style that reflected the fundamentals of American Colonial architecture. For the first 40 years, the school and the manner in which they treated patients avoided the scrutiny of the public.

DANGER
ASBESTOS
CANCER AND LUNG DISEASE HAZARD
AUTHORIZED PERSONNEL ONLY
RESPIRATORS AND PROTECTIVE
CLOTHING ARE REQUIRED IN THIS AREA
DANGER
NO TRESPASSING
TUNNEL BLOCKED
NO EXIT

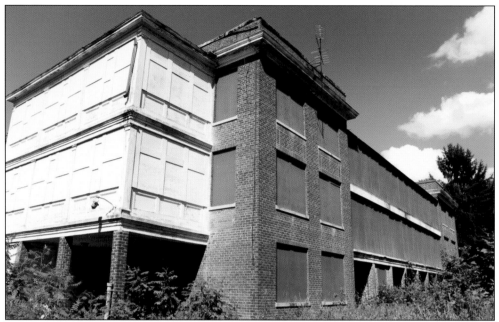

Belchertown soon housed over 700 young patients. To the outside world, all seemed well, but inside there lived great suffering. At this time, the state schools of the area differed from state hospitals. The hospitals were for the mentally ill, while state schools were institutions for the "mentally defective."

"Mentally defective" was used to describe a person who had been determined by a lawful authority to be of marked subnormal intelligence, a danger to himself or herself or to others, or who lacked the mental capacity to manage his or her own affairs. "Mentally ill" described a person with maladaptive behavior and impaired functioning, caused by genetic, physical, chemical, biological, psychological, or social and cultural factors.

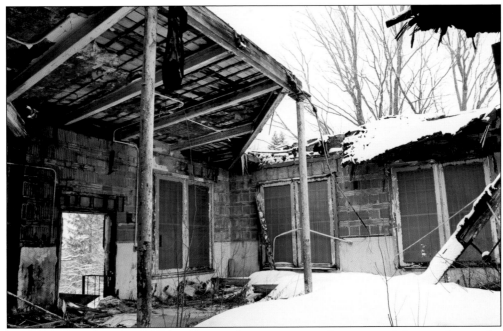

In the 1960s and 1970s, the school began drawing unwanted attention. It became known for inhumane treatment and neglect of the patients. Deplorable conditions and consistent staffing issues left many patients partially, and in some cases completely, undressed and laying in their soiled beds—causing chronic sores and infections.

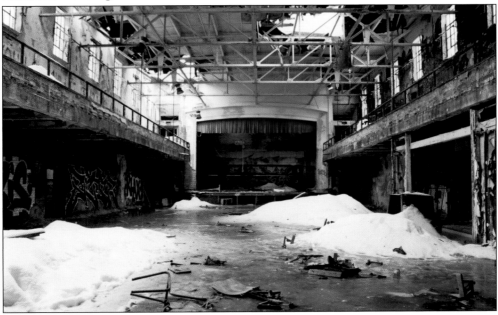

In the 1960s, during the Kennedy administration, a new era of mental health care began. The Community Mental Health Centers Act of 1963 advocated treating people with mental illnesses locally, instead of in isolated state hospitals, and opened the door to the construction of federally funded community mental health centers across the United States. This included several facilities in Massachusetts. Seen here is the Belchertown auditorium.

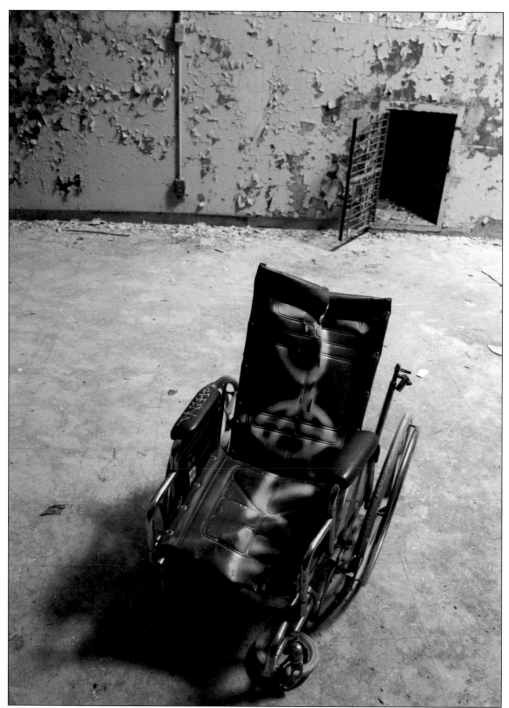

During this time, there was an increase in awareness of those with intellectual or mental disabilities as individuals with human rights. This was at least in part due to the civil rights movement. In 1966, Massachusetts passed the Mental Health and Retardation Services Act, which mandated a gradual transition from a few institutions around the state to a more community-based system of care facilities.

In 1972, Dr. Benjamin Ricci, whose son was a patient at Belchertown, filed a class-action lawsuit against the school, claiming that its young residents were living in deplorable conditions. The plaintiffs referred to the conditions at the hospital as "horrific," "medieval," and "barbaric." Belchertown State School became a benchmark of what was wrong with care for the mentally ill and disabled at the time.

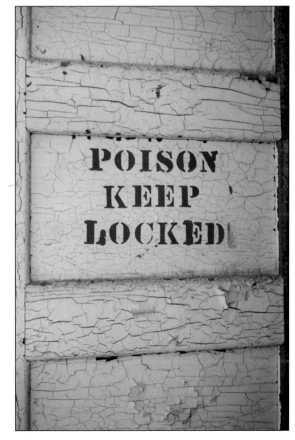

After Dr. Ricci filed the landmark lawsuit against Massachusetts, US District judge Joseph L. Tauro visited Belchertown State School. After spending hours at the facility, Judge Tauro emerged with a horrifying understanding of how the facility was run and what patients faced every day. "I had never felt so punched out," Tauro said. "The horrors I saw were things I couldn't imagine."

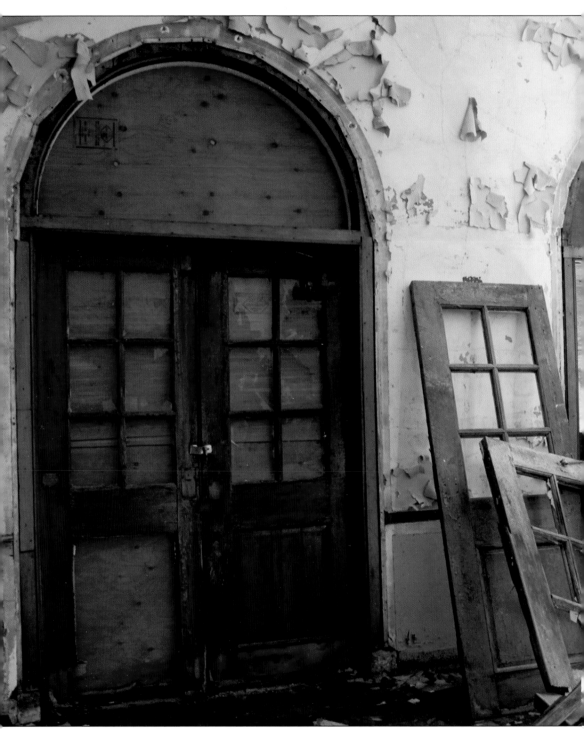

Judge Tauro's decision in the case against the Commonwealth of Massachusetts forced the state to spend millions of additional dollars on care, including hiring more staff to help care for the patients and giving them appropriate training to do so. These care facilities were also ordered to create individual lifetime treatment plans for thousands of mentally disabled residents, many of

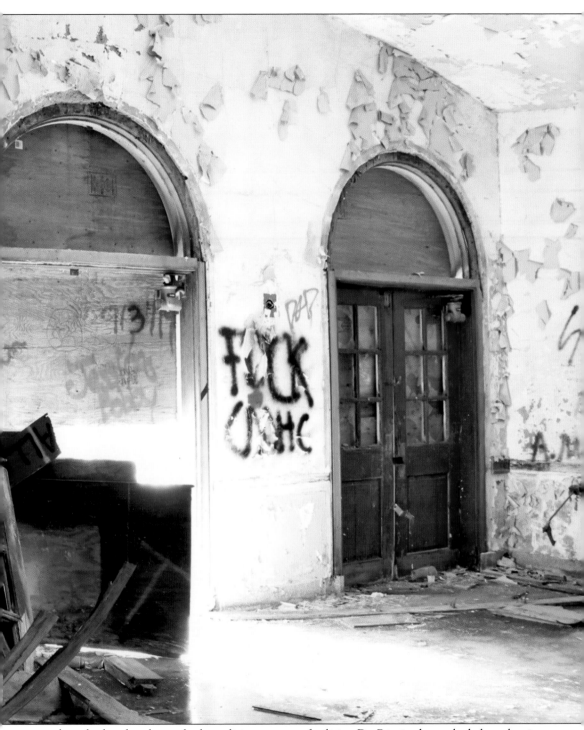

whom had endured wretched conditions at state facilities. Dr. Ricci, when asked about leaving his six-year-old son Robert at the facility back in the 1950s, explained, "Once a child had been diagnosed as retarded in those days, an institution was the only choice. We had two other youngsters at home. I didn't have the guts to look back at him."

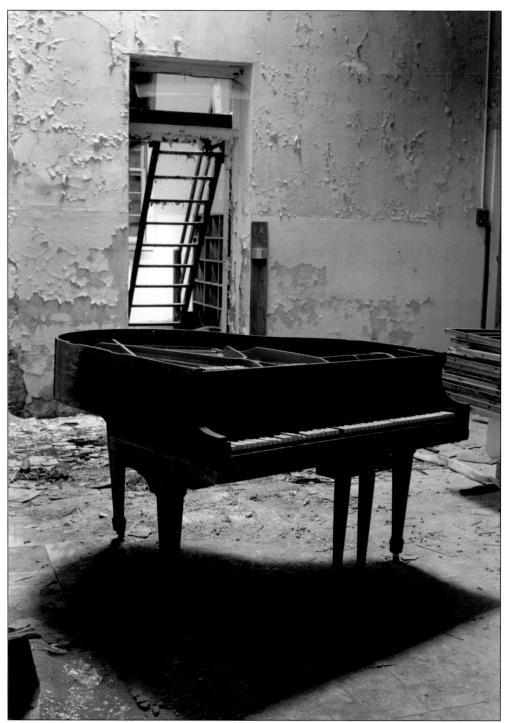

Over nearly two decades, whenever Dr. Ricci's son Robert would visit his family, they noticed his head was shaved and covered with scabs and bruises. Patients were exposed to deplorable conditions, such as being left undressed in the hall, drinking from contaminated dishes, and blatant neglect of patients by overworked and understaffed faculty.

Dr. Ricci's frustration grew until he filed a lawsuit alleging inhumane conditions at the school. The case of Ricci v. Greenblatt, so named for the state's mental health commissioner, Milton Greenblatt, opened the door to change. The lawsuit eventually affected other state institutions and resulted in a court order requiring the Department of Mental Retardation to dramatically improve its services.

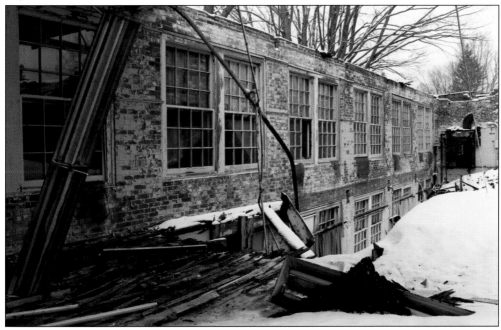

In an interview with the *Boston Globe* in 2006, Gerald J. Morrissey Jr., commissioner of the Massachusetts Department of Mental Retardation, said, "Ben will always be known as a pioneer—a fearless and tireless advocate on behalf of individuals and families. He has revolutionized the care and support for persons with mental retardation in Massachusetts."

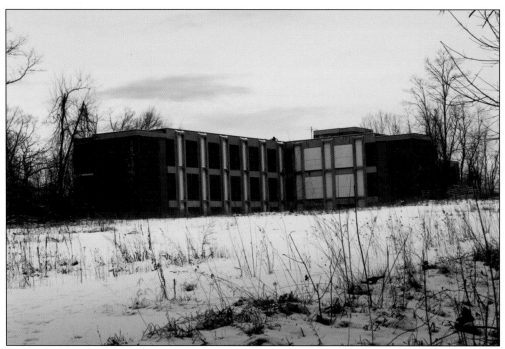

On December 23, 1992, the last resident of Belchertown State School departed. For more than two decades since, the question on the minds of every resident of the town has been the fate of the former school's grounds. Though there have been several attempts, efforts to clear the property, and properly dispose of the hazardous materials left behind, have all proven too expensive and extensive to implement.

Demolition of the derelict facility was set to begin in May 2015. The newest plan for the property involved a $15 million, 83-unit assisted living facility. Associated Building Wreckers of Springfield was hired under a $904,939 contract for the demolition and cleaning up of hazardous materials in advance, including asbestos.

The demolition also includes the removal of six structures: the hospital building, three cottages, a trailer and a small barn, and tunnels. Both town and state officials praised the newest efforts. State senator Eric P. Lesser called it an "exciting new chapter" that will "serve as an engine of economic growth for the town and broader region."

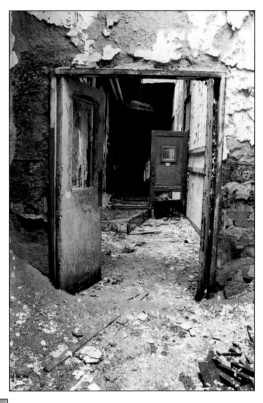

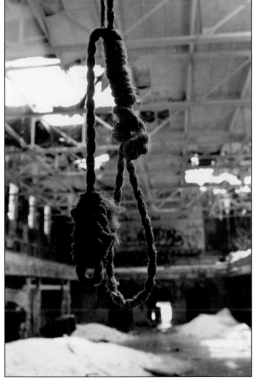

Further demolition is planned, which may rest on the success of the current phase of the project. Though similar efforts have failed in recent years, officials are optimistic. The major change in this attempt is the state's participation and financial support to aid in the clean-up of the environmental hazards, making the economics of building more realistic.

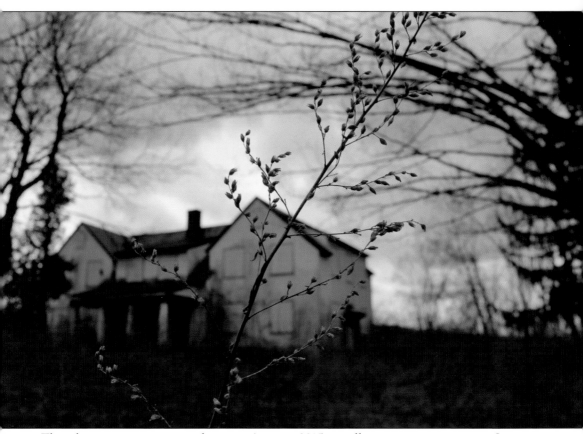

Though construction is set to begin in Autumn 2015, it still is not written in stone. Current plans involve a large elderly housing facility, with more land cleared than necessary in the hopes of attracting more businesses that will create jobs and tax revenue.

Two

MONSON STATE HOSPITAL

42°8'34"N 72°19'36"W

The Story of May

At the tender age of eight, May suffered from chronic seizures. She had been admitted to Boston Children's Hospital, which at the time was unable to accommodate her needs. In the fall of 1960, she was transferred to Monson State Hospital. She lived there on and off between 1960 and 1973, at a time before much-needed advances in the mental health field had been put into place.

At about the time May was admitted, newer treatments were being introduced into the field. Since the beginning of the 20th century, the sedative and hypnotic properties of barbiturates have been explored, and by the 1960s these drugs were commonly used in the treatment of seizures. These sedatives and a regimen of muscle relaxants were administered, along with a usual course of electroconvulsive therapy. These shock treatments were typically given two or three times per week until the patient showed no further signs of seizure.

May recalled the way the medications made her feel. She spoke of a dissociative feeling, as if she were in a dreamlike state. "I would lie in bed all day long, trying to break out of the stupor. Other patients would stare out the window, the wall, or ceiling. I had no idea what day it was or even if it were light outside. It was a horrible existence."

Monson State Hospital, like many in those days, was tremendously understaffed, and those who worked there lacked both the training and the desire to properly care for patients. While the most common sin of these employees was neglect, some where verbally and physically abusive. May recalled one man, whom she called "Billy," that had shown her some kindness. "Whenever Billy came around, he could always make me smile. He would speak softly to me, and before he left he'd be sure I had my dolly. It's funny how such a simple thing could have such an enormous impact on a little girl. No matter how scared I was, I had seeing him to look forward to. Even now, whenever I think of him, I smile."

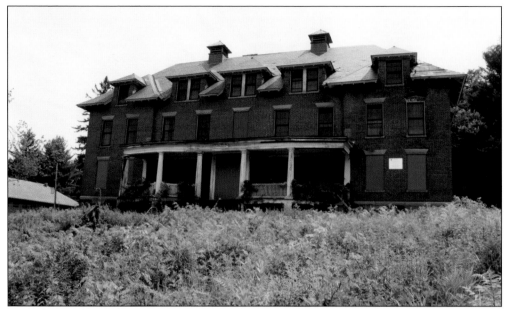

According to the Massachusetts State Archives, "The State Almshouse at Monson, MA provided residence for paupers without settlement [legal residence] in the Commonwealth from 1854 to 1872. The State Primary School opened at the almshouse in 1866 and continued after its closing until 1895, providing lodging, instruction, and employment for dependent and neglected children under age sixteen without settlement in the Commonwealth and some juvenile offenders." Seen here is the Quabbin Building.

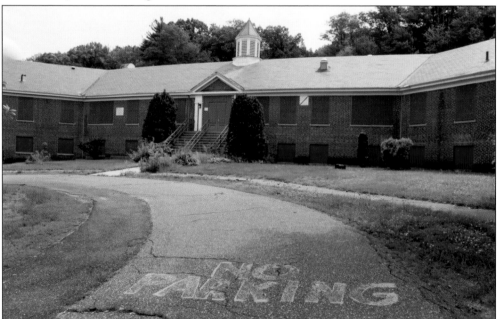

In 1895, Monson State Almshouse was converted into the Massachusetts Hospital for Epileptics; the third of its kind in the country after Ohio in 1892 and New York in 1894. It had also been called the State Primary School at Monson Hospital, Public School, and State Hospital and was the Monson Developmental Center when it closed in 2012.

The Monson Developmental Center opened in 1854 and at its peak in 1968 housed as many as 1,700 of the state's most vulnerable citizens. The State Primary School opened at the State Almshouse at Monson in 1866 and continued to operate until 1895—well after the almshouse's closed in 1872. It provided lodging, instruction, and employment for dependent and neglected children under age 16 without anywhere to live.

Even though the Monson Developmental Center was added to the National Register of Historic Places in 1994, by 2008 Gov. Deval L. Patrick had announced that the facility would be closed in an effort to save the commonwealth a projected $42 million over a four-year period. It was one of several facilities in the state that would be closed in this cost-cutting effort.

At the time of the announcement, there was a push by the state to relocate developmentally disabled residents into community-based group homes. These facilities were intended to mirror home environments more closely. Monson State Hospital still had 137 severely disabled full-time residents and 403 employees. This image shows a seating area near a residential building on campus.

After the announcement, the facility's population continued to decline, though the process of closing took another few years to complete. By 2012, there were 216 full-time employees and 31 residents remaining, who would transition to new or existing state-operated homes. The last remaining residents moved out that summer. This wind chime was likely made by a patient.

In 2012, with the hospital's official closing, the question on the minds of officials and residents was what would become of the massive property. Since the mid-19th century, the Monson Developmental Center had catered to people with severe developmental disabilities and later the severely mentally disabled.

With the center slated to close, many wondered what would become of this massive, 688-acre chunk of property that sat on State Avenue in Monson, near the Palmer town line. Like many of the facilities of the time, the problem—and main concern—was the safety of the residents.

The facility's buildings are old and present major ecological problems. If the state property were to be sold to a private interest, the new owners—as well as those caring for the facility—would face substantial costs rehabilitating the site. Common building materials from the turn of the 20th century include asbestos and lead paint, problems that are compounded by an aging heating plant.

Much like other facilities built around the same time, Monson Developmental Center functioned like its own small city. With both a power plant and water tower on the grounds, it was self-sustaining. With Monson closed, it left only two of the commonwealth's state-run institutions open: Wrentham Developmental Center in Wrentham and the Charles Hogan Developmental Center in Danvers.

The closing of Monson State Hospital left few options for the residents as well. Some went to live with relatives, while others were put into remaining institutions or group homes in and around the community. The shift to group housing was tricky, with only seven state-run group homes: two in North Brookfield, two in Ware, and the remaining three in Monson, which accommodated about 30 residents.

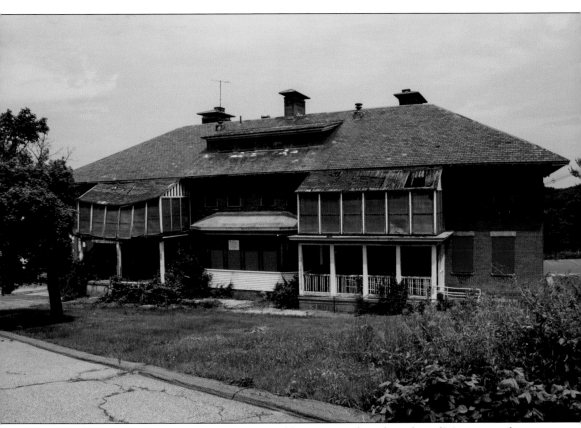

Local officials were concerned with what it would mean regarding the safety of Monson residents. Town administrator Gretchen E. Neggers said, "Our immediate concern is how the facility is going to be left and how we are able to provide the necessary security. I had been hopeful we could have been working together a lot more closely."

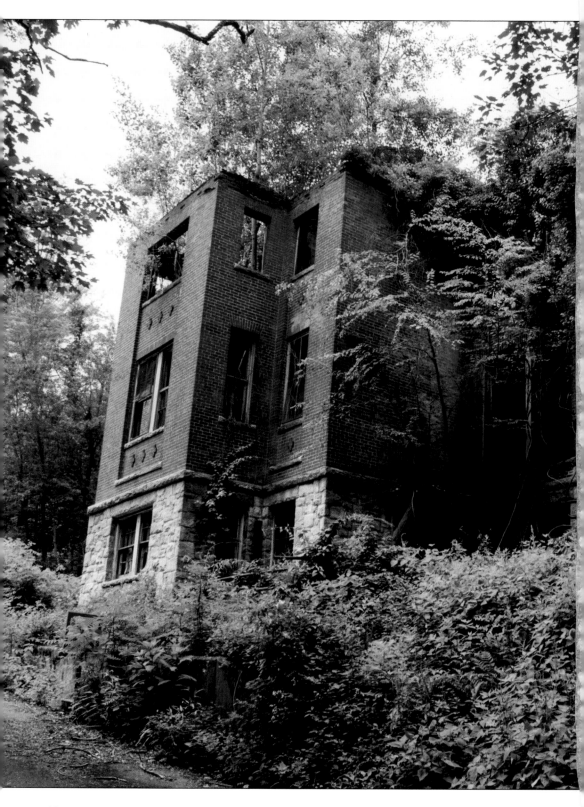

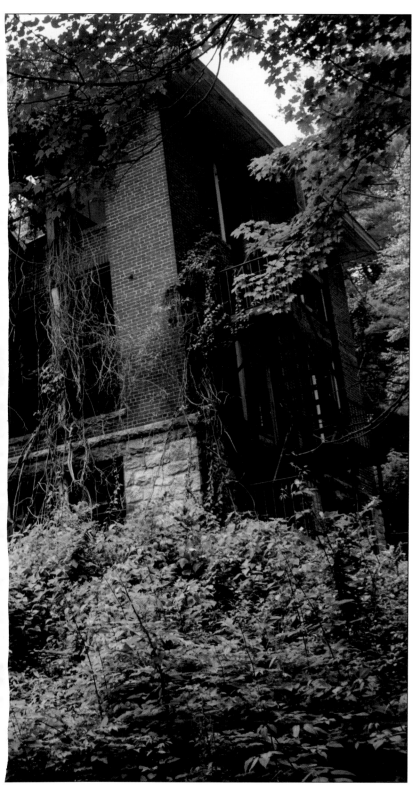

As had been prevalent in several other abandoned state hospitals and schools in Massachusetts, authorities worried about the safety of town residents. These buildings had been constructed with materials now known to be hazardous. Asbestos and lead paint were widely used for many years before they were discovered to be carcinogens. On top of the ecological consequences, many of these buildings were in a state of disrepair. The concern extended to the safety of local kids and urban explorers who would break in for various reasons. Not fully understanding the danger associated with being in this type of environment, trespassers were subject to injury as well as long-term health consequences.

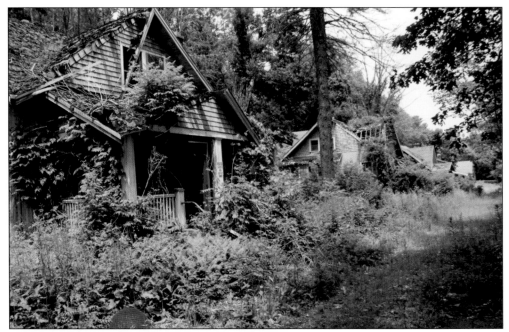

Monson town officials had hoped the state would step in to either secure the dangerous buildings or tear them down. They hoped for a "master plan" as Selectman Edward S. Harrison put it. It was a master plan that did not come to fruition. Other valid concerns were brought up, such as the sprinkler system being turned off, which could possibly lead to fires.

Fire of practically any size had the potential to release harmful toxins into the air, which would cause more problems than destruction of property. Beyond these issues of safety, many similar institutions have remained vacant for decades. With clean-up costs reaching into the millions, no suitable solution has been approved. The fate of Monson State Hospital remains unclear.

Three

WESTBOROUGH
STATE HOSPITAL

42.3011° N, 71.6103° W

The Story of John

"I worked there [at Westborough State Hospital] as a security guard for many years. The things I'd seen . . . let's just say, it was no picnic for us or the inmates." John worked as a guard at Westboro State Hospital, beginning in the 1960s. He worked overnights, which meant he had less contact with the patients, or "inmates" as he called them, in their waking hours, but he was all too familiar with the atrocities inflicted upon them. "It was scary for the inmates sure, but it was scary for us too," John shared, "there were times when I just wanted to leave and not look back. I was much younger then, and I hadn't seen much of the world. I had no idea how cruel people could be."

Nighttime was the worst for John. When all the patients were asleep, medicated heavily, he knew he was alone. As the shadows deepened, every creak or ping of the pipes echoed through the halls and sent chills up his spine. For him, this feeling came not just from the eerie atmosphere of the darkened asylum, but thoughts of what the patients had endured throughout the day. Patients would cry and scream when the nurses came to give them their medications. They were often hit and held down, with no consideration given to their aversion to treatment. Of this, John said, "I couldn't blame them. They were so heavily medicated, many of them never got out of bed."

John also noted, "But it wasn't all bad. Some days, especially more in the later seventies, the windows would be open to allow the sun and fresh air in. It amazed me to see how much the inmates liked it." Westborough State Hospital had a dairy, as well as a farm, where many of the patients worked and grew all of their own vegetables. Patients who were able would play games like bingo and checkers. There were times when laughter and dancing filled the halls.

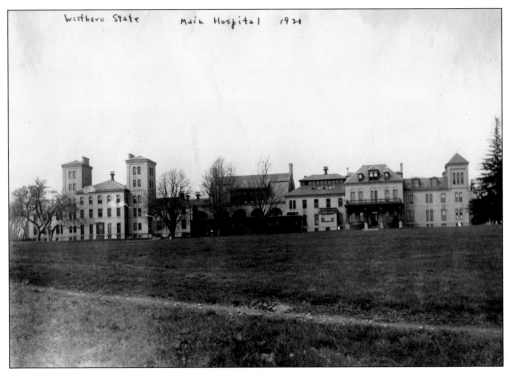

Dr. Solomon Carter Fuller was a pioneer and stands as an extraordinary model of determination and achievement. He was an early-20th-century psychiatrist, researcher, and medical educator, who was born on August 11, 1872, in Monrovia, Liberia. The main Westborough hospital and administration building is pictured here in 1921. (Courtesy of the Westborough Historical Society.)

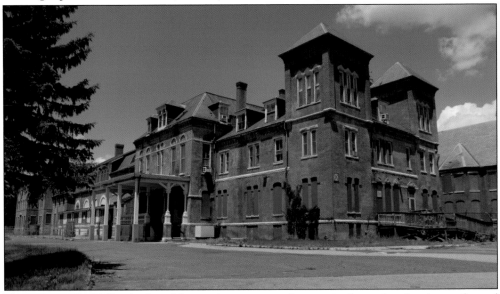

Not only was Dr. Fuller the first African American psychiatrist in the nation, he also performed landmark research that would help shape the field of neuropathology and secure his place among the innovators of the mental health field. He spent the bulk of his career practicing at Westborough State Hospital. Pictured is the hospital's current administration and hospital building.

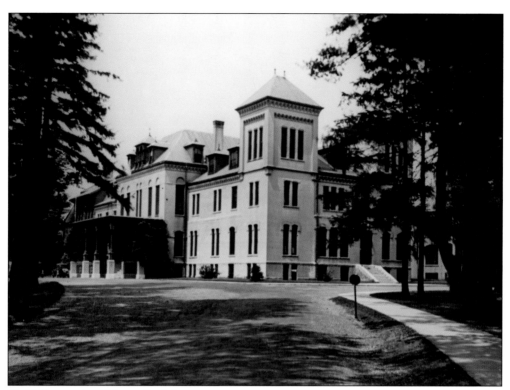

Dr. Fuller received his medical degree from Boston University School of Medicine in 1897. Through much of his early professional career (1899–1933), Dr. Fuller was employed by his alma mater, where the highest position he attained was associate professor. (Courtesy of the Westborough Historical Society.)

Dr. Fuller accepted an appointment at Westborough State Hospital for the Insane and worked there as a pathologist for 22 years, eventually becoming the chief pathologist. He then served as a consultant for another 23 years.

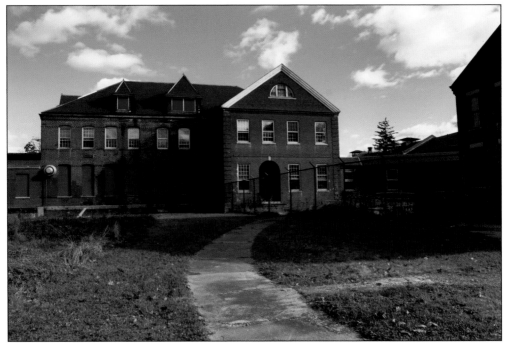

Dr. Fuller spent his time at Westborough concentrating on analyzing the brain tissue of cadavers who had been diagnosed with various mental illnesses in life. This led to groundbreaking research on Alzheimer's disease and the physical changes to the brain.

Dr. Fuller found plaque composed of abnormal protein deposits in various tissues of the body and tangles of threadlike parts of neurons in brain tissue that are now known to be one of the hallmarks of Alzheimer disease. Pictured here is the Westborough tunnel entrance.

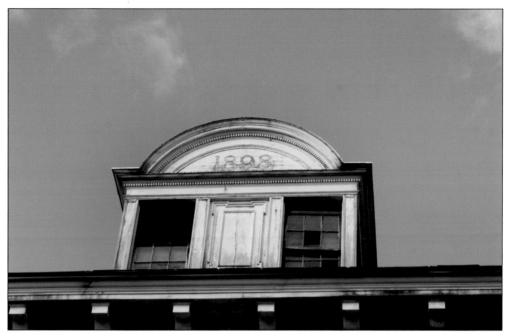

In 1904 and 1905, Dr. Fuller worked under Alois Alzheimer at the University of Munich in his study of the pathology of mental illnesses. Through the research done there, Dr. Alzheimer announced his discovery of the disease that bears his name. Prior to this, people with "senile dementia" were considered insane. Pictured here is the Talbot building.

Though Dr. Fuller's work helped support Alzheimer's initial conclusion that dementia is caused by disease, not aging, Dr. Fuller was well respected in his own right. His importance to the field of psychiatry is built on his groundbreaking work in neuropathology and psychiatry, as well as rising above the factor of race at a turbulent time in this country.

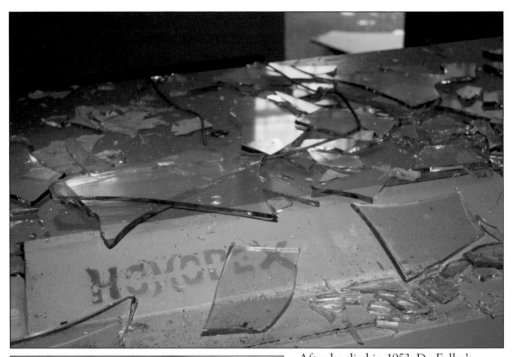

After he died in 1953, Dr. Fuller's obituary was published in the New England Journal of Medicine. In 1974, Boston University dedicated the Dr. Solomon Carter Fuller Mental Health Center. Dr. Fuller's portrait also hangs among those of psychiatry's founding fathers at the American Psychological Association's headquarters in Washington, DC. Pictured is the front desk of Westborough's administration building.

In 1907, Dr. Fuller wrote, "The writer believes . . . after due consideration of the objections which have been raised, that alterations in the neurofibrils which might well be considered pathological, may be demonstrated in the cerebral cortex of persons dying insane."

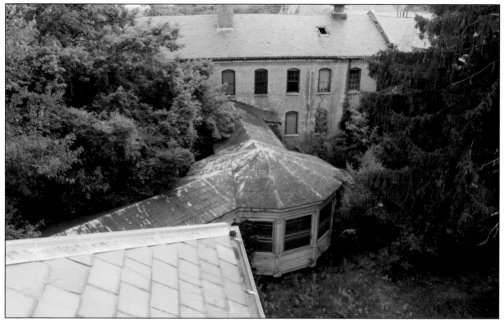

In 1911, the *American Journal of Insanity* published Dr. Fuller's paper on plaque in the brains of older adults. It states, "The central point of this study has been the miliary plaques commonly found in the brains of persons dying at an advanced age. Consideration, however, has been given to many other factors which might have a causative relationship, or at least serve as an explanation for these peculiar structures." (AJI 68: 147, 1911) This photograph was taken from the attic of the Westborough administration building.

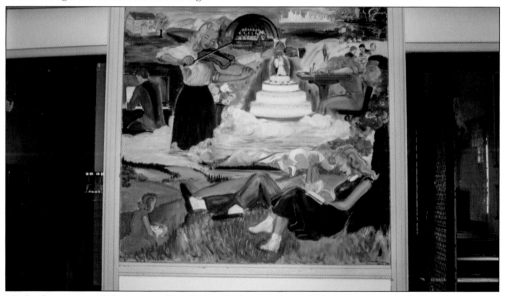

He further writes, "The onset of senile involution varies in different persons and this may explain the presence of plaques in the brains of some elderly persons and their absence in others. . . . The plaques were the deposits in brain tissue of a chemical substance resulting from pathological metabolism of nervous elements." This mural from inside the administration building was painted in 1952.

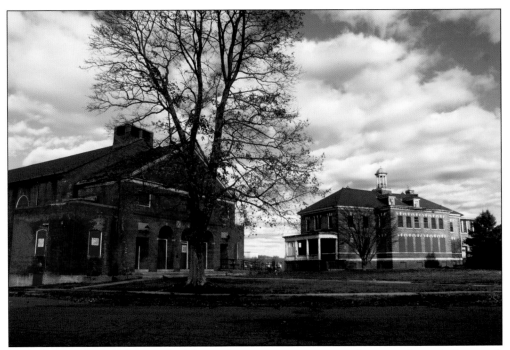

Dr. Fuller was also an advocate for African American war veterans, who were often misdiagnosed, discharged from the military, and often declared ineligible for military benefits. His work at the Veteran's Hospital in Tuskegee, Alabama, training young doctors how to properly diagnose these patients preceded the well-known, unethical Tuskegee syphilis experiments (1932–1972).

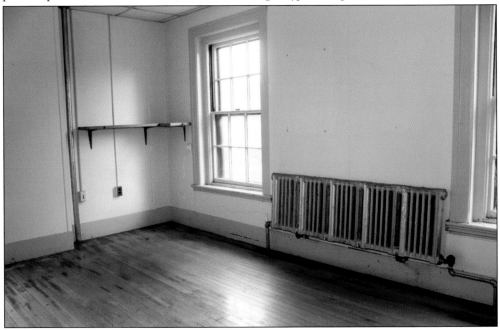

Launched by the Black Psychiatrists of America in 1974, the Solomon Carter Fuller Program was housed at the Solomon Carter Fuller Mental Health Center in Boston. By the mid-1970s, it served as a viable alternative for young African Americans seeking a residency program in psychiatry.

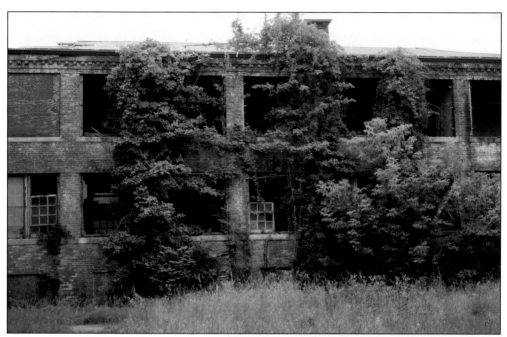

Built in 1884, Westborough State Hospital was also formally known as Westborough Insane Asylum and Westborough State Hospital for the Insane.

Changes in the mental health field in Massachusetts began between the 1950s and 1970s. New insights into issues of mental health expanded the field, and many people who would have been institutionalized could now be treated on an outpatient basis. This reduced the populations in the state schools and state hospitals.

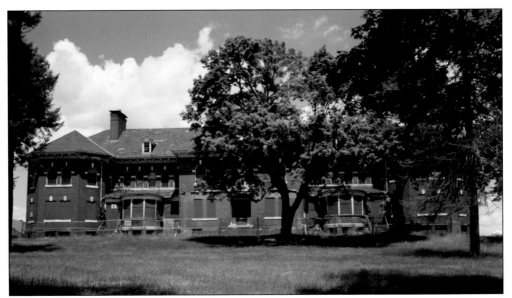

By 2005, the number of those residing within Westborough State Hospital had fallen off, and it was hard to justify maintaining the more than 60 buildings and 600 acres of property. As a result, the Department of Mental Health decided to close the Westborough campus.

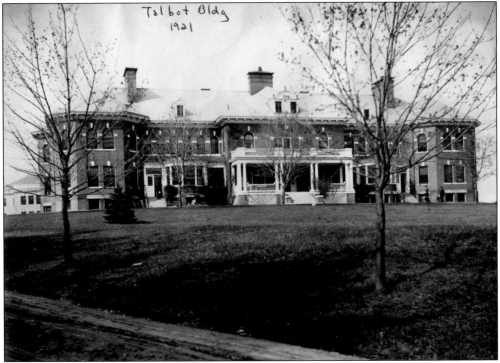

While it was added to the National Register of Historic Places in 2010, Westborough was closed that year. The 10-bed Deaf Unit, the two Adolescent Units, and the Intensive Residential Treatment Program were all closed by June 2010. The last remaining patients were transferred to Worcester State Hospital on April 11 of that year in anticipation of a new Worcester State Hospital opening in 2012. (Courtesy of Westborough Historical Society.)

The extensive property, spattered with brick buildings, once sat on the shores of Lake Chauncey and served thousands of adults and adolescents struggling with mental illness. Shortly after the hospital's closing, the commonwealth hired a consultant who determined that the "highest and best use" of the property would be to build hundreds of single-family homes.

Patients of Westboro State Hospital came from all over the state. In the 1970s and 1980, families were left with few options in regard to care for loved ones who were deemed a burden. Family doctors often told parents of mentally disabled children there was no other option than to put them away in a place such as this. Too often, after they were left in the care of the hospital, the families cut off all contact. This familiar story was true for over 500 of those patients over the 126 years the hospital was open.

These flags mark grave markers that were recently dug out from under a foot of dirt by a local Eagle Scout troop. When patients passed away, their remains often went unclaimed and were subsequently buried in a potter's field. There were no services or other memorial. The dead were simply put in a cardboard box at Pine Grove Cemetery and buried. The only testament to their existence was a small marker bearing only a number.

On May 9, 2015, a memorial service was held in nearby Pine Grove Cemetery for the more than 500 patients who died at Westborough State Hospital. The service was part of a larger effort to put names to the graves of the deceased, give them their due respect, and give voice to their struggle. Seen here is one of the markers that the Eagle Scout troop uncovered.

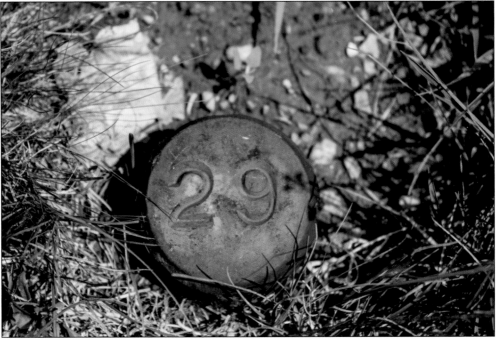

Since 2010, the nearly 300-acre state hospital property on Lyman Street, on the Westborough-Northborough town line, has been empty. In 2013, the Town of Westborough signed a $2.2 million agreement with the Division of Capital Asset Management and Maintenance to purchase and develop 95 acres. Scott Jordan, state undersecretary of Administration and Finance, said the agreement allows the state to work with the town as a silent partner.

In July 2014, the Town of Westborough purchased the former Westborough State Hospital property from the Commonwealth of Massachusetts. The town reached an agreement with the Division of Capital Asset Management and Maintenance to acquire 95 acres, with waterfront access and scenic views, without restrictions. Several developers and businesses have already expressed an interest in owning some of the property, including a film studio and a medical device company.

The State Hospital Reuse Committee was formed by the Board of Selectmen to explore the future use of the property's resources and to cultivate recommendations. The committee is composed of representatives of town boards and commissions, the town manager, the town planner, and local residents. "This is one of the most important things we have done as a community in many, many years," Selectman George Barrette said. "It is one of the last enormous pieces of land in town, but to have the control over how it is developed is really the most important part." This photograph shows the inside of the administration building.

Four

MEDFIELD
STATE HOSPITAL

42°12 48 N71°20 10 W

The Story of Medfield State Hospital

On May 1, 1896, acting governor Roger Walcott established the Medfield Insane Asylum for the Chronic Insane. In 1902, the hospital joined the state's other mental health facilities in the Commonwealth of Massachusetts as an admission and treatment center rather than a transfer institution to relieve overcrowding.

Stories of abuse, neglect, and even fatalities were commonplace throughout the field of mental health at the time. Overcrowding and understaffing were only part of the problem. Due to the misunderstanding of the mental conditions and rampant cruelty from those intended as caregivers, many injuries and deaths of patients went unnoticed. In 1916, an attendant named Wesley Linton pleaded guilty to the assault, beating, and killing of a patient. Though he had a history of abusing patients, he was sentenced to only three years in the Dedham House of Corrections.

Prior to World War I, there were 362 employees at the hospital. In 1917 alone, 51 employees left to serve in the war, where 44 saw active duty in France and four more were killed. During this time, the hospital housed inmates from the Charlestown Jail due to overcrowding.

Despite the hospital's battle to operate with diminished funding during the Great Depression, the administrators were able to build a machine shop and a paint shop. The Hillside House, built in 1931, served as living quarters for the physician and his family before eventually becoming the home of the assistant superintendent.

In 1938, along with the barbarism of electroshock treatments being used for the first time at Medfield State Hospital, there were several patient deaths. Two patients were killed as a result of assault by employees and two more by unsupervised patients. State officials also launched a major investigation over the disappearance of a large supply of narcotics. Complaints continued due to overcrowding and limited staff well into the 1940s.

With the outbreak of World War II, the hospital again faced a significant staff shortage, and the "more reliable patients" took over the care of other patients, as well as the laundry, food services, housekeeping, the farm, and the grounds. They shoveled coal and snow and did an excellent job despite never being compensated for all of their work.

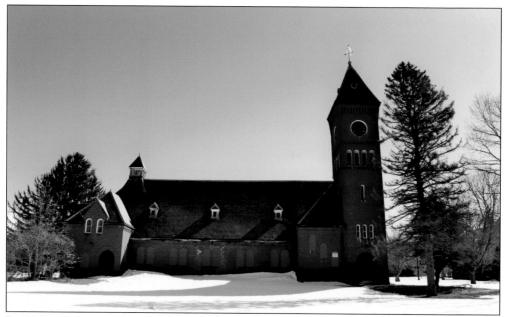

In 1890, a state commission began plans for the future asylum with property purchased from the estates of Judge Robert Bishop and Moses Bishop, as well as the Morrill farm in the north end of Medfield. Within two years, Massachusetts, through an act of the state legislature, founded the Medfield Asylum.

The campus would ultimately expand to over 900 acres and nearly 60 buildings, but at the time of the initial purchase it had 22 buildings over several hundred acres. That same year, civil engineers began laying the groundwork for the facility. By 1894, construction had begun, and the bare bones of the new asylum took root.

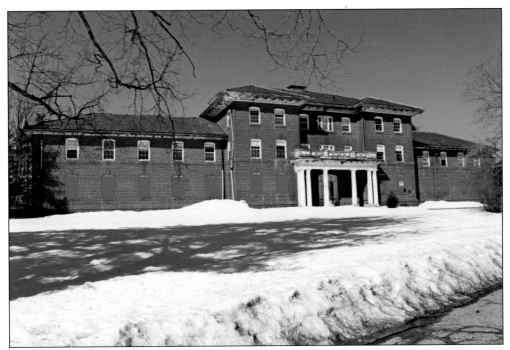

Medfield was the first state mental hospital in Massachusetts to be constructed with individual buildings that allowed for better light and ventilation. This so-called "cottage plan" was designed by William Pitt Wentworth and was intended to make the living conditions more homelike. The sleeping quarters were on the second floor, while sitting and work rooms were on the ground floor.

Construction was mostly completed by 1895, but it took another year before it opened. Of the 25 buildings, 18 were for patient housing, and the remaining buildings were to be used for administration, a kitchen, and laundry. The two sweeping dining rooms were able to each accommodate 400 patients at a time. St. Jude's Chapel rounded the campus off, all of which had been under the direction of Supt. Norman Clark.

Into the last century, Medfield was known as a strong agricultural contributor to the area. On the grounds of Medfield State Hospital, on hundreds of acres, was a well-maintained farm. Built opposite of the campus of the hospital was a large barn to hold the harvest. The 1865 construction was later updated with living quarters for the head farmer and his family.

On May 1, 1896, acting governor Roger Walcott establishing the Medfield Insane Asylum for the Chronic Insane. With 120 patients arriving at the soft opening of the hospital, it was quite the spectacle of the day, with people of the town crowding street corners to catch a glimpse of the new residents.

These initial patients came from the Taunton Insane Asylum and later from Danvers, Northampton, Westborough, and Boston. Medfield State Hospital had initially been built to relieve the overcrowding of other state facilities. Within the first 10 years, the number of patients had grown to 1,554.

At its peak, the facility employed as many 500 to 900 doctors, nurses, cooks, and support staff. The population of the hospital had grown greater than that of the town. The staff worked 12-hour shifts six days a week. Since staff housing was not completed until 1904, employees lived on the wards with the patients or slept in attics of the buildings where they worked.

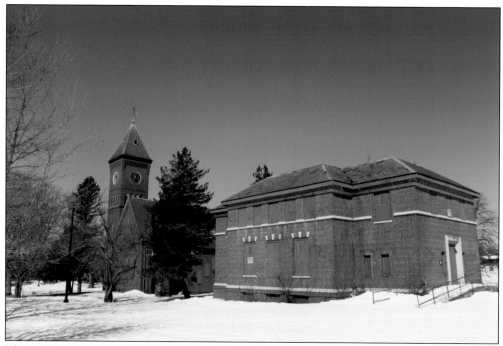

The asylum was renamed Medfield State Hospital in 1914, but little else changed, especially for residents. Patient deaths averaged four a week and often had been surrendered to the care of the state, and thus many of the remains went unclaimed. The superintendent of the asylum secured slate headstones for patient graves.

Initially a tomb was erected in the asylum lot at Vine Lake Cemetery, where patients were laid to rest until the influenza epidemic of 1918. A second cemetery location was chosen on state land near the Charles River. The deaths, as well as other deficits in patient care, did not go unnoticed.

It had become a common occurrence for patients to wander into the yards of townspeople, amble through the town center, or hitchhike on the roads.

By the 1950s, the popularity of new psychiatric medications had spread to Massachusetts. These treatments made it possible for many of those who were previously facing a lifetime of institutionalization to leave the hospital, with some to group homes and others directly into the community.

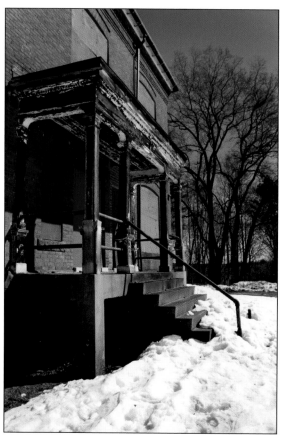

Continuing with the sense of it being a self-sufficient, town-like campus, the Clark Building was constructed in 1958 to serve as the medical hospital for Medfield State Hospital. Before this time, medical emergencies such as broken arms and other minor operations had taken place in area hospitals.

It was around this time that Dr. Harold Lee had taken over Medfield State Hospital. He introduced a program of patient training for independent living and improved work skills. This offered many patients, who had previously no hope of leaving the asylum, the possibility of making a transition into the community. By the 1960s, more than 100 patients had been discharged using Dr. Lee's step system for self-sufficiency.

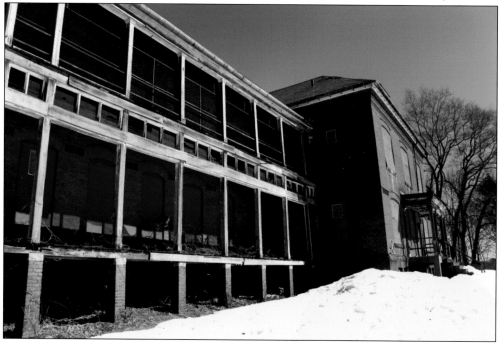

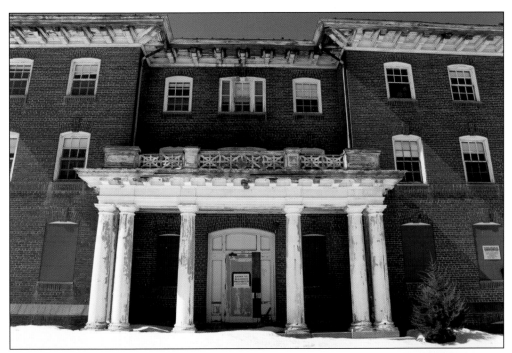

Some of these work skills came from working at the hospital. Prior to the late 1960s, the farm played an important role in the lives of patients and the economy of the hospital. By this time, the hospital had a total of 609 acre of land, 184 of which were under cultivation.

Tons of corn were held in the farm's silos, as well as carrots and other vegetables in root cellars in the back fields. Along with milk from the dairy cows, a herd of more than 1,000 cattle and 3,000 chickens served much of the food needs for not only Medfield, but other state-run facilities.

In the 1960s, the population of Medfield Hospital, as well as similar hospitals, began to drop due to changes in the treatment of mental health patients as well as laws governing them. Its decline continued, like many similar asylums in Massachusetts, until it was closed on April 3, 2003.

Among other New England hospitals, Medfield State Hospital was featured in the major motion picture *Shutter Island*. The main building and the first two wards of the fictional Ashecliffe Hospital for the Criminally Insane were filmed at the abandoned Medfield State Hospital. The facility was also seen in Richard Kelly's *The Box*. The looming brick buildings and sprawling lawns were key assets of the location.

Five

McLean Hospital and Metropolitan State Hospital

42.3937° N, 71.1911° W and 42.4089° N, 71.2128° W

The Story of the Asylum on the Hill and the Met

In Belmont, Massachusetts, McLean Hospital—otherwise known as the "Asylum on the Hill"—stands out from the other asylums of the time due to its popularity with famous clientele. Parallels between mental illness and creativity have sometimes been drawn, as many of McLean's patients have enjoyed successful careers as writers, musicians, and artists. The institution was soon renowned for ministering to prominent, creative, and aristocratic patients.

Robert Lowell, a Pulitzer Prize–winning poet, was admitted to McLean Hospital in 1958. He stayed there four times over a span of eight years. Suffering from manic depression, he had become known for his manic outbursts and had numerous stays at other mental institutions. Although his depression was at times difficult for Lowell and his family, some speculate that it is what made his poetry so provocative. In fact, in his poem "Waking in the Blue" he makes reference to his stay there.

Conversely, Metropolitan State Hospital earned its reputation in the wake of a tragedy. Inspiring headlines like "Murder at the Met," the allure of this case came not only from the murder itself, but from its alleged cover-up. Local authorities showed outrage at the mishandling and destruction of potential evidence in an apparent attempt to sweep it under the rug. "It took eight months of intensive investigation by the attorney general's office to obtain the evidence needed to bring the charges against Wilson," said Assistant Attorney General Robert Bohn in a statement to the press. Despite this, there was no arraignment for two years.

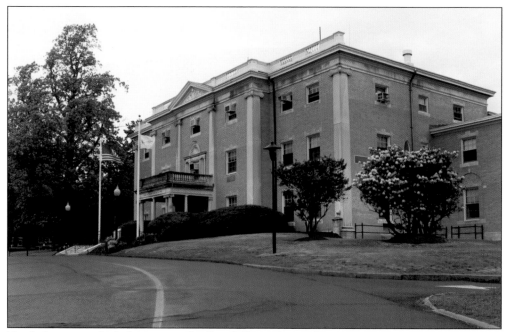

Nestled amongst the lush greens and rolling hills on the outskirts of Boston, this impressive brick and stone building may have been mistaken for a mansion. McLean State Hospital was founded on February 25, 1811, through a charter granted by the Massachusetts Legislature. This was the main building of the hospital.

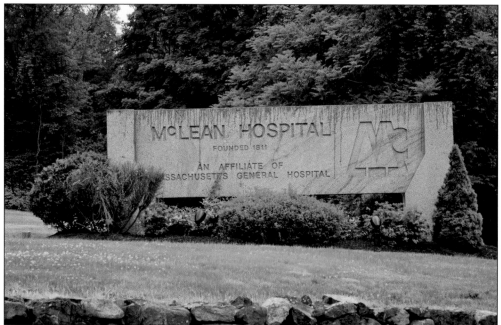

McLean Hospital was first known as an "asylum for the insane" and was a division of the Massachusetts General Hospital. It was named in honor of one of its earliest benefactors, a Boston merchant who bequeathed $25,000, and left a residuary legacy of more than $90,000, to the asylum.

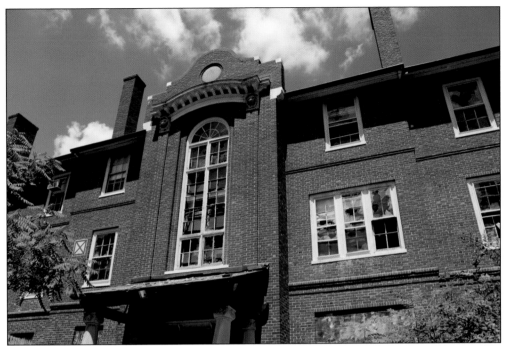

In the earlier days, it was not uncommon to see doctors and patients enjoying recreation together. McLean's patients, who were most often wealthy, enjoyed large rooms with fireplaces, parlors, and private bathrooms. They enjoyed horseback riding, skiing, tennis, skating, horseback riding, golf, and croquet on the hospital's vast lawns. Pictured is an abandoned section of the McLean building.

The McLean grounds were also home to a working farm, art studios, billiard rooms, bowling alleys, and gymnasiums. Typical stays at McLean often only lasted for weeks or days, as opposed to the months and years spent at other area asylums. In the 1990s, faced with much political debate and falling revenues of the health-care industry, the hospital drafted a plan to sell a percentage of its grounds. The pictured section of McLean is still in use.

A town development plan for the property includes a mix of residential and commercial real estate. The deal was finalized in 2005, and land development was well under way by the end of the year. Today, McLean Hospital is the largest psychiatric affiliate of Harvard Medical School. The facility is well known for its treatment of adolescents, especially those with borderline personality disorder: a mental disorder characterized by unstable moods, behavior, and relationships.

McLean Hospital also stands out among similar facilities in Massachusetts and New England thanks to its combination of teaching, treatment, and research, where other facilities focus on just one of these priorities. Among its accolades, the hospital "developed and implemented national health screenings for alcohol, depression, and memory disorders."

In 2014, the Society for Neuroscience, which is "the world's largest organization of scientists and physicians devoted to understanding the brain and nervous system," awarded the Julius Axelrod Prize to Joseph T. Coyle, MD, chief scientific officer and chief of the Division of Basic Neuroscience at McLean Hospital. The Julius Axelrod Prize recognizes exceptional achievements in neuropharmacology and in mentoring young scientists.

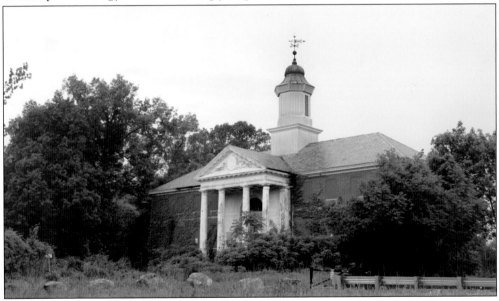

Construction began on Metropolitan State Hospital in 1927 on a parcel of land spanning the towns of Waltham, Lexington, and Belmont. The hospital was demolished in 2009 and replaced with an apartment complex. Though thousands of patients passed through its doors, the hospital was infamous for a tragedy. Pictured here is the William F. McLaughlin Administration Building.

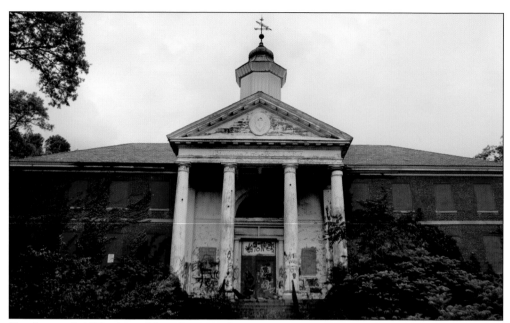

On August 9, 1978, Anne Marie Davee, a longtime patient at Metropolitan State Hospital, was given permission by the ward physician to walk around the hospital's grounds without an escort. The caregivers who worked closely with her felt that she was ready for challenge. Unfortunately, by afternoon, she had not returned. Concerned, the doctor on duty contacted state and local police.

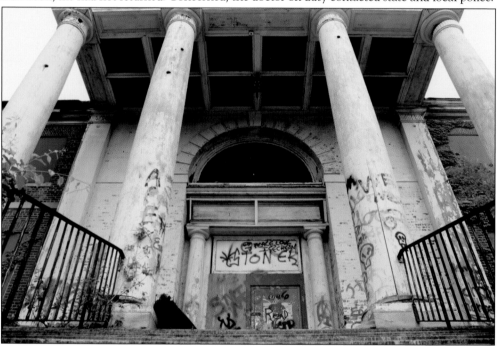

Two months after the disappearance of Ms. Davee, there had been little done to find her. In an effort to move the investigation along, a search of the personal possessions of the main suspect in her disappearance was conducted. Found among fellow patient Melvin W. Wilson's belongings were several photographs that had belonged to Ms. Davee, as well as seven of her teeth.

The gruesome discovery prompted another search for what may have remained of the missing woman. Focusing more on the search for evidence related to a murder led investigators to a landscaping shed. Inside it they found the victim's clothing, a pocketbook, and small case tied together in a bundle. In her pocketbook was a hatchet, which was later determined to be the murder weapon.

Two years after Anne Marie's disappearance, fellow patient Melvin W. Wilson was officially charged with her murder. Finally, on August 12, 1980, Wilson led police and hospital authorities to where he had buried her dismembered remains, bring closure to the case. He was then taken to Bridgewater State Hospital (a secure forensic hospital), and Metropolitan State Hospital earned the moniker, "The Hospital of the Seven Teeth."

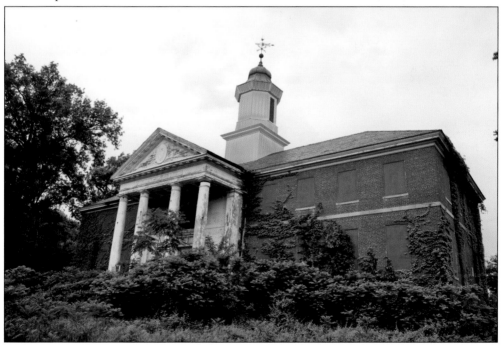

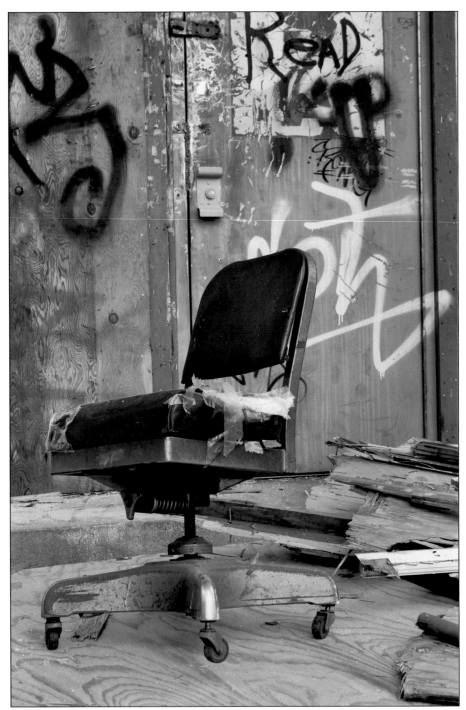

The disappearance and murder of Anne Marie Davee was just one on a list of unexplained deaths at state institutions. At the time of Wilson's arrest, authorities such as Sen. Jack H. Backman spoke of at least 26 other patients who had died under questionable situations. Suicides, bathtub drownings, chokings on food, and heart attacks were considered questionable because the statistics were too high for the state institutions.

Six

TAUNTON STATE HOSPITAL AND LAKEVILLE STATE HOSPITAL

41.9119° N, 71.1006° W and 41.8762° N, 70.9277° W

The Story of Jane

Jane Toppan (1857–1938), born Honora Kelley, was an American serial killer. Her mother, Bridget Kelley, died of tuberculosis when Jane was young. This left Jane and her siblings in the care of their father, Peter Kelley. Mr. Kelly was known as eccentric and an alcoholic, which earned him the nickname, "Kelley the Crack." A few years after his wife's death, Kelley brought his two youngest children, eight-year-old Delia Josephine and six-year-old Honora, to the Boston Female Asylum. Future records would indicate that the surrendered girls were "rescued from a very miserable home."

In November 1864, Honora Kelley was placed as an indentured servant in the home of Mr. and Mrs. Toppan of Lowell, Massachusetts. The family legally adopted Nora in 1859, and she changed her first name to Jane. She seemed to be an intelligent, well-balanced young woman until she was jilted by her fiancée years later. After several suicide attempts, she seemed to move past the betrayal and became a nursing student around 1880.

Though she was asked to leave school prior to earning her certificate—due to the mysterious deaths of several of her patients—Jane forged the paperwork necessary to work as a private nurse. On July 4, 1901, an old friend, Mattie Davis, died under Jane's care at Cambridge. Retained as the family nurse by patriarch Alden Davis, Jane poisoned one daughter, Annie Gordon, on July 29. The father's death a few days later was blamed on a stroke, but when his surviving daughter, Mary Gibbs, died unexpectedly on August 19, Mary's husband demanded an autopsy. Lethal doses of morphine were found in all three victims.

In all, Jane confessed to 31 murders and named her victims, but many believed her actual tally was much higher. She was declared insane after telling the court, "That is my ambition, to have killed more people—more helpless people—than any man or woman who has ever lived." She was confined to the state asylum at Taunton, Massachusetts, where she died in August 1938 at aged 84. She was remembered by the staff as "a quiet old lady."

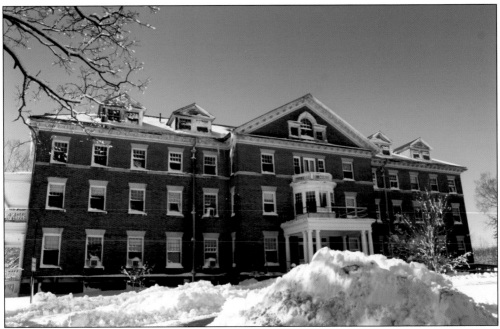

Elbridge Boyden was a well-known architect in Massachusetts in the mid-1800s. Though he was well known outside of New England, he earned local notoriety with his designs of both Mechanic's Hall and Holy Cross College. When the Massachusetts General Court assembled a commission to investigate possible locations for the new facility, Boyden was asked to provide the design.

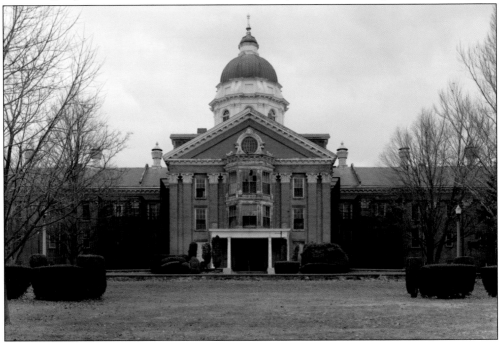

Much of Boyden's craftsmanship can still be seen today. He worked mostly using cast iron in both functional and decorative aspects of his designs of domes and cornices of many public buildings. (Courtesy of the Library of Congress.)

Throughout the area, Boyden was responsible for the design of many state and federal buildings. The mark of his period architecture could be seen in post offices, railroad stations, courthouses, and town and city buildings, as well as some privately owned facilities like churches, hotels, and banks. Built in 1853, the Taunton Lunatic Asylum sat on a 164-acre farm just north of Taunton town center, reflecting a popular asylum design of the time referred to as the Kirkbride Plan.

Dr. Thomas Story Kirkbride designed an asylum with a hierarchical segregation of residents according to gender and symptoms of illness. This "linear plan" featured a central administration building flanked by two wings. Each wing was broken up into wards, with the more "excited" patients placed on the lower floors and farther from the central administrative structure. Patients who proved less volatile were put on the upper floors, closer to the administrative center.

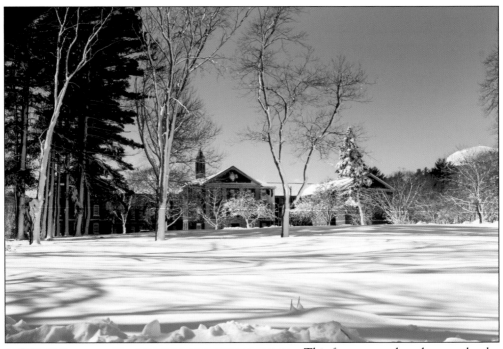

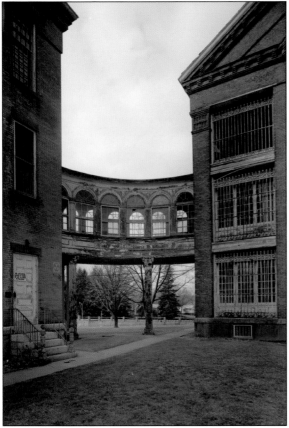

This format was thought to make the asylum experience more comfortable for stable patients. Isolating them from more aggressive patients, it allowed them the benefits of fresh air, natural light, and views of the asylum grounds from all sides of each ward. Taunton received its first patient on April 7, 1854, and in the span of eight weeks it took in 250 more. This campus is still in use.

Taunton grew into what was essentially a city within a city. It was the second institution of its kind built in Massachusetts after 1833's Worcester State Hospital became dangerously overcrowded. By 1873, the state legislature appropriated funds to expand the hospital due to it being overcrowded by about 400 patients. Pictured is a former building at Taunton State Hospital. (Courtesy of the Library of Congress.)

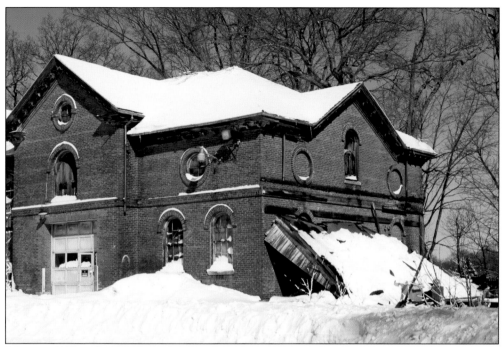

Between 1887 and 1906, a series of construction projects developed the campus. There was also further construction in the 1930s. These projects saw the development of juvenile facilities, crisis centers, sick wards, and on-grounds group homes.

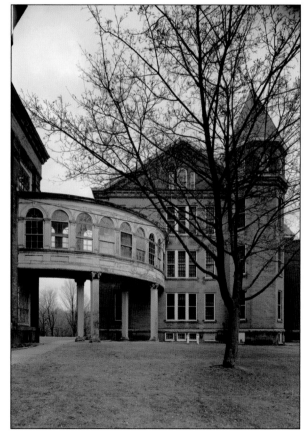

An asylum was envisioned as a place of organized activity that also offered respite from suspected causes of illness and had a certain amount of medical therapy. All of these were intended to cure mental disorders and improve patients' lives in general. Pictured here is the old, now-demolished Taunton State Hospital. (Courtesy of the Library of Congress.)

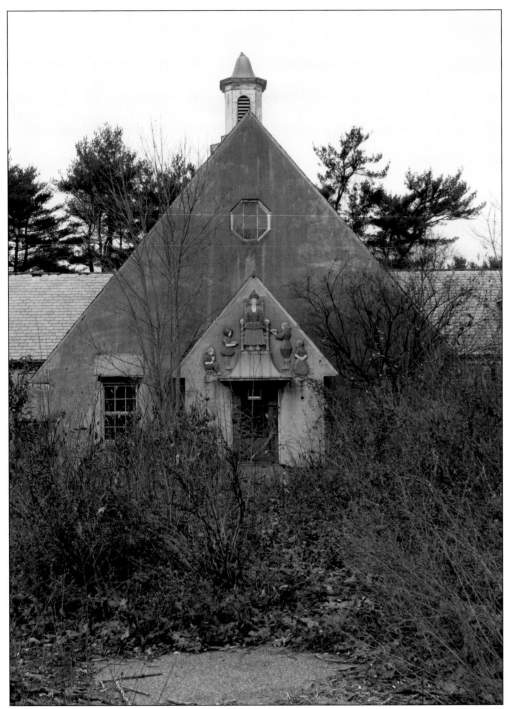

Lakeville State Sanatorium was one of three state institutions authorized to join the Massachusetts State Sanatorium at Rutland in caring for tuberculosis patients. The hospital was first used to quarantine patients who had tuberculosis and orthopedic tuberculosis. Placed under the authority of the Trustees of Hospitals of Consumptives, Lakeville opened its doors in 1910 and housed 150 patients.

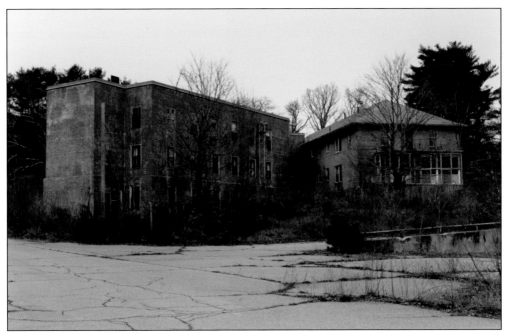

The early decades of the Lakeville's existence were rife with stories of neglect and abuse. There are several accounts of children as old as eight or nine being confined to cribs with metal bars, where they were tied down and left in their own filth. Others spoke of taunting and outright cruelty perpetrated by the staff. The main campus is pictured here.

In 1946, after a treatment for tuberculosis was discovered, the sanatorium began treating patients with polio, spastic paralysis, muscular dystrophy, arthritis, and other crippling conditions. In 1954, it began providing care for the aged, and in 1957 care was offered to persons with chronic diseases.

Originally called Lakeville State Sanatorium, Lakeville Hospital was given its new name in 1963. A mere 30 years later, it closed under Gov. William Weld's administration when the Special Commission for the Study of the Consolidation of State Facilities decided to close it to save money.

The 73-acre site of the former hospital, valued at $5.1 million, remained vacant until 2002 when it was purchased by National Development. The plans included a large shopping plaza, office buildings, and a senior housing complex, as well as a 100-unit senior living facility. Though plans seemed to be moving along, and the necessary permits were issued, delays in acquiring service with water and sewer squashed the planned development.

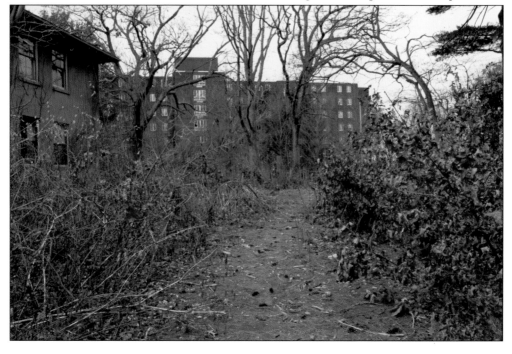

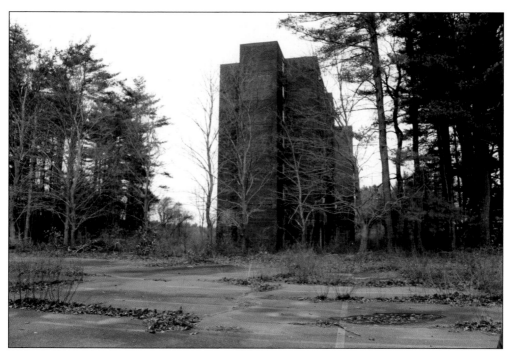

An attempt at developing the property was once again made in 2010 when Sysco Corporation showed interest in the land. Sysco is one of the largest food-service companies in the country.

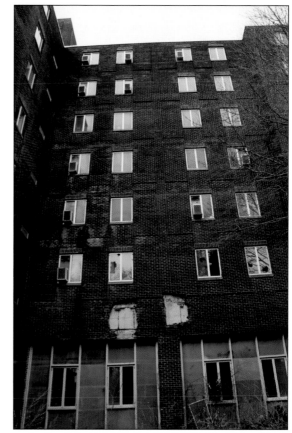

A development plan for a 650,000-square-foot food distribution center was set to move forward. Special 13-year financing was agreed upon, which would have allowed for a small tax break for the $110 million deal.

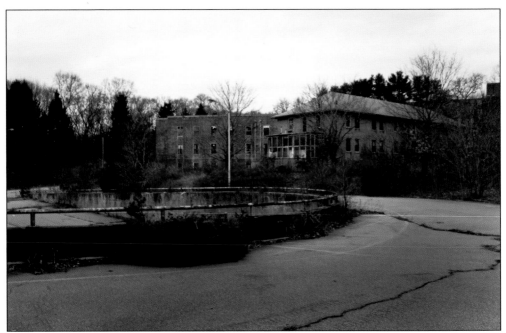

Though the property of the former hospital was not zoned for industrial purposes, Sysco and local officials had hoped for certain zoning variances. Financing had been approved, and officials hoped they could push through a proposal for an industrial overlay district. The vote went to area residents, but due to fear of increased traffic and noise the needed variances were narrowly defeated.

The asylum currently lies empty, like many other institutions of the time. With development tied up in committees and politics, its future remains as uncertain as many of those who passed through its doors.

Seven

WALTER FERNALD
STATE SCHOOL

42.3911° N, 71.2106° W

The Story of Eugenics

At first, the idea of eugenics, the study of human improvement by genetic means, seemed ambiguous. Its history goes back centuries, when it was thought that arraigned marriages between men and women of wealth and distinction would result in a higher class of offspring. In the not-so-distant past, eugenics painted a much clearer picture of unethical experimentation and practices upon those entrusted to oversee state-run institutions.

Beginning in the early 1900s, laws permitted the sterilization of those deemed insane, retarded, or epileptic. In 1907, Indiana was the first US state to pass such laws, but by 1936 it had been joined by 34 other states. The story of American eugenics includes the sterilization of tens of thousands of people nationwide in the first half of the 20th century. It is widely thought of as barbaric and unethical now, but organizations thought of as advocates for ethical treatment today had supported eugenics in the past as a means to a so-called "progressive society."

Orphans or people from poor families or broken homes, and those deemed "morons, idiots, and imbeciles," were held in state institutions like Fernald as if they were criminals. The list of people considered unfit to procreate grew to include delinquents and epileptics, and they were sterilized without consent and often without the knowledge of the patient.

The idea of eugenics came under scrutiny after the unspeakable events of World War II, when the German Nazis used the science to support the extermination of Jews, people of color, and homosexuals. Even after this, there were reports of isolated instances of involuntary sterilization into the 1970s.

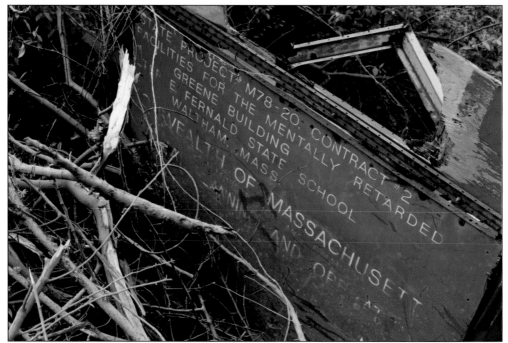

The Massachusetts School for the Feeble-Minded was founded by Samuel Gridley Howe in 1848 with the intention of making clean, productive, responsible citizens of high-functioning, disabled youths. Later, it was renamed to the Walter Fernald State School and is now operating as the Fernald Development Center. It is the oldest institution in the western hemisphere caring for people with developmental disabilities.

Some of the programs instituted in the earlier days included classroom training and manual training at shoe repair, broom making, rag rug making, weaving, knitting, sewing, housekeeping, music therapy, dancing, and athletics. By the 1870s, the school faced increased pressure to accommodate adults with chronic disabilities that required consistent custodial care.

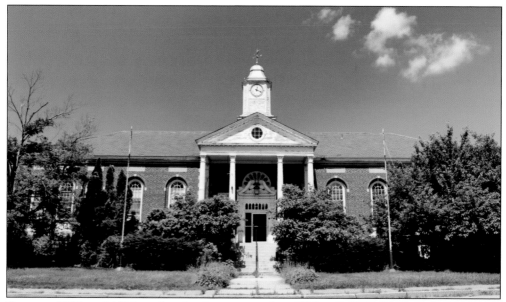

Between 1888 and 1924, under third superintendent Walter E. Fernald, the school became internationally renowned as an authority in the treatment of the mentally retarded. Under Fernald's guidance, the school took on a more scientifically focused approach to treatment. This was at a time when eugenics practices were common in an attempt to remove certain "undesirables," often the poor and developmentally disabled, from the gene pool.

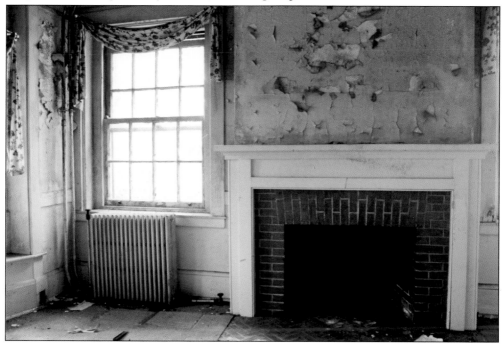

By 1887, the school had outgrown its facilities, and the legislature allotted $25,000 for the purchase of land in Waltham. The first purchase was the 18-acre Bird estate—located off of Waverley Oaks Road—and in 1888, construction began on the school's campus in Waltham. By its peak in the 1960s, the number of residents had reached 2,600.

With major changes to US laws and regulations, by 1979 the number of residents had decreased to 1,161. These boys, who had been confined to the Fernald State School from the 1940s to the 1970s, found themselves either on their own or placed into more residential-style institutions. Pictured here are the living quarters.

These patients were often held based on a single faulty intelligence test. Considered to be "morons," "imbeciles," and less than human, they often had no possible way of being released and were completely at the mercy of the state-run institution.

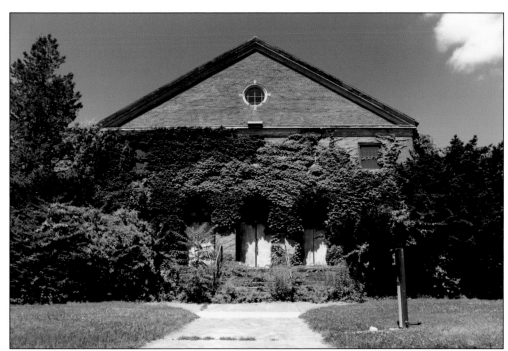

Experiments were performed at the institution, where exclusive meals containing minute amounts of radioactive iron and calcium tracers were given to patients so researchers could trace the path of food and determine how long it took to get through the digestive system. Though admittedly the exposure was low, MIT and the Quaker Oats Company paid $1.85 million to the children who were exposed back in the 1940s and 1950s.

When these experiments were performed, the actions of researchers technically fell under their set of ethical and protocol guidelines; however, many still saw their exploitation of the boys to be morally deviant. Those select patients were invited to a "science club," the name of the group of unknowing participants. They were given special privileges beyond the uncommon servings of both oatmeal and milk every day, with any extra helpings they asked for, unaware of the true intentions of the researchers.

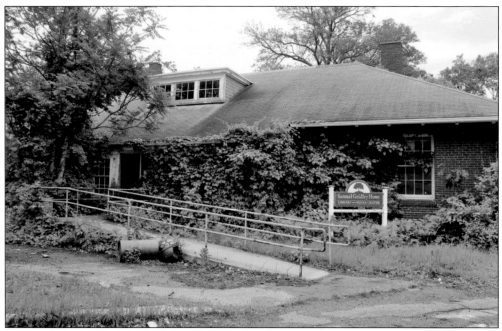

Members of this "science club" who participated in the study for Quaker Oats, as well the scientists from the Nutritional Biochemistry Laboratories at MIT, were also allowed games and access to activities. These incentives included special assemblies, gifts, or trips to Boston Red Sox games; however, neither the boys, nor their families, were made aware of the nature of the experiments.

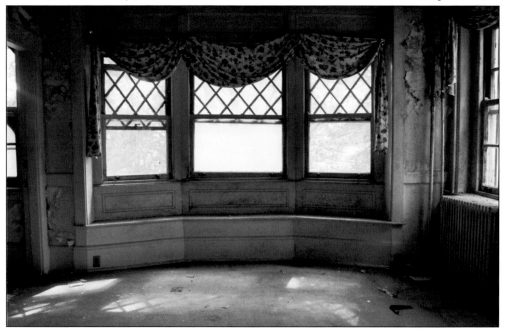

Through reports found in public documents, it was determined that the program participants chosen were considered "marginal" or "unimportant," which may have been used to justify using this abhorrent treatment. It may also explain why both patients and their families were not informed of these experiments until a half century later.

Though this experiment is one of the well-known incidents, there were a few other similar experiments done at Fernald and other establishments. According to a report by doctoral candidate Doe West, who had been appointed to serve as project coordinator, primary researcher, and author of the task force, there were records of earlier experiments involving children with mental impairment.

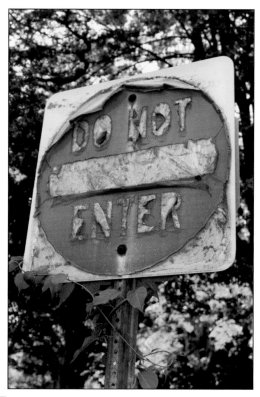

Dr. West went on to detail a third set of studies between 1952 and 1961. They were performed at both Fernald and Wrentham State School and investigated thyroid function in children with mental impairment using an isotope called Iodine-131. This was considered one of the most dangerous fission products of uranium. It was of special concern, as Iodine-131 was produced for cold war purposes and the meals were not nutritional as had been in the previous study.

According to Dr. West's report, "The cold war thyroid experiment at Wrentham [and Fernald] was designed to investigate human uptake of radioactive iodine from the milk supply following a nuclear incident or attack. . . . The subjects were 70 children ranging in age between 1 to 11 years."

Despite efforts to save the facility, under the Gov. Deval Patrick administration it was determined that Fernald had become too costly and that there were better ways to provide care, such as private, community-based settings, for the remaining Fernald residents. By June 2013, only 13 residents lived on the grounds. The Walter E. Fernald Developmental Center was shut down on November 13, 2014.

Eight

Paul A. Dever State School

41.9440° N, 71.1215° W

The Story of Fort Myles Standish

Before it was the Paul A. Dever School, the campus was Fort Myles Standish. It served as a military port for American soldiers shipping off, and returning from, overseas fighting during World War II. In addition to being a port and training stopover, it also served as a prisoner-of-war camp, holding hundreds of Italian and German soldiers.

On March 29, 1944, the camp took in 500 Italian soldiers. While the Italians were officially considered co-belligerents, they were said to have been treated well and even allowed passes to go into the town. Although they were not initially welcomed in town, they did find some allies among Italian American residents. While held in Taunton, the Italians were supposed to have military escorts whenever they left the camp, but it was common for them to find holes in security and sneak out. Their forays into town became so common that the town's busses would stop at the gate as well as two holes in the fence. In fact, after the war ended and they were released to return to their country, several hundred Italian soldiers who had found wives in and around town eventually returned to the United States.

The German soldiers were a different story. They were held away from American troops as well as the Italian prisoners. They were kept under constant guard and were escorted to and from their meals. In total, about 3,000 German soldiers and 4,000 Italian soldiers were held at Camp Myles Standish throughout World War II. When the war ended in 1945, they were returned to their respective countries, having been treated well.

Soon, the camp emptied of military personnel and civilian workers were laid off, and on January 11, 1946, the camp was officially decommissioned. In the 1950s, the camp was sold back to the state for $1 and set aside as the future site of the Myles Standish School for the Mentally Retarded. The name was later changed to the Paul A. Dever School.

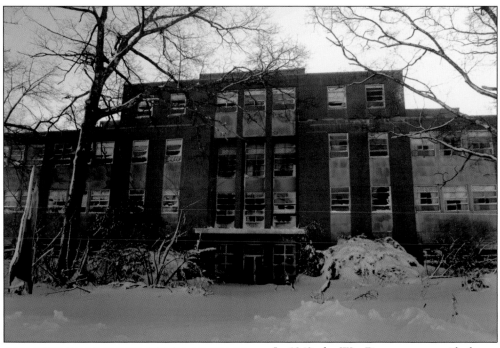

In 1942, the War Department notified the City of Taunton that it would be using over 1,600 acres of land for a US Army camp. The camp would serve as a port for hundreds of thousands of American and Allied soldiers shipping out overseas. Later, it served as a receiving station for troops returning from Europe and a holding area for both German and Italian prisoners of war.

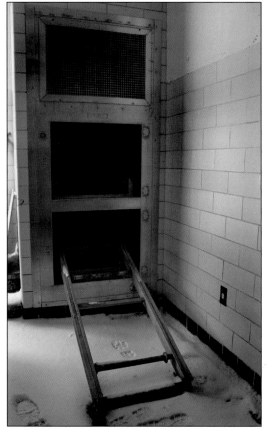

The entrance to the camp is marked by a low stone monument, which was dedicated by the Taunton Allied Veterans Council in 1961. It reads, "To commemorate the site of Camp Myles Standish, the major troop staging area of the Boston port of embarkation through which 1,531,711 personnel were processed from October 1942 to January 1946 and sent forth to engage in World War II." The morgue is pictured here.

The campgrounds contained 35 miles of paved roads and nearly 1,500 structures, including more than 600 barracks. There were 500 to 700 civilian workers and 39,000 soldiers at the camp at any given time, rivaling nearby Taunton's population of 43,000. Camp Myles Standish, which was named for the first commander of the early colonial army, was the third largest camp in the United States thanks to its proximity to the port of Boston. Pictured is the X-ray room.

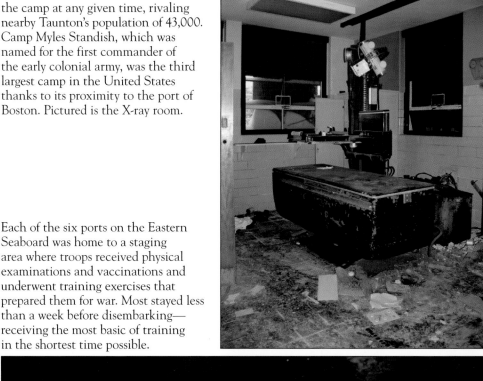

Each of the six ports on the Eastern Seaboard was home to a staging area where troops received physical examinations and vaccinations and underwent training exercises that prepared them for war. Most stayed less than a week before disembarking— receiving the most basic of training in the shortest time possible.

When the war ended and the federal government no longer needed the property, it was handed back over to the state. Soon, patients were brought to the former camp and housed in the camp hospital. The former Camp Myles Standish was renamed to the Myles Standish School for the Mentally Retarded.

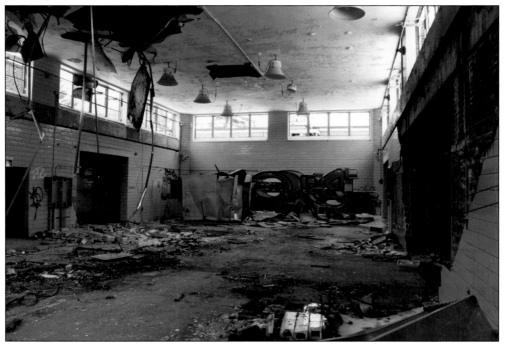

Gov. Paul A. Dever approved funding for the expansion to 24 additional buildings in 1951. The new brick buildings were intended for use by the handicapped patients on the updated grounds of the Massachusetts prisoner-of-war camp.

In 1955, the population of American mental institutions reached its peak at about 560,000 nationwide. Moving forward, a policy of deinstitutionalization was enacted, and by the 1990s the numbers of residents had dropped to well below 100,000. The move toward deinstitutionalization has eliminated over 90 percent of former state psychiatric hospital beds.

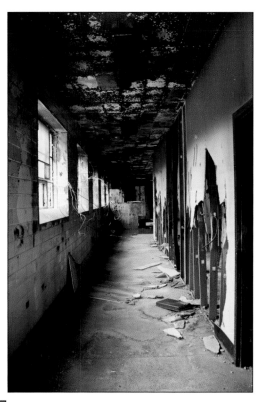

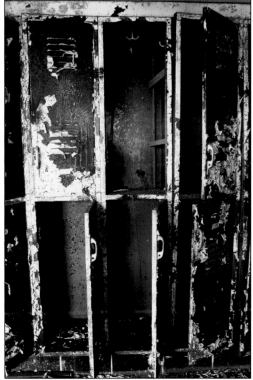

In 1959, the Myles Standish School for the Mentally Retarded was renamed the Paul A. Dever State School after the late Massachusetts governor who served from 1949 to 1953. The original property consisted of 15 L-shaped dormitory buildings on 1,200 acres that were connected by a mile and a half of tunnels.

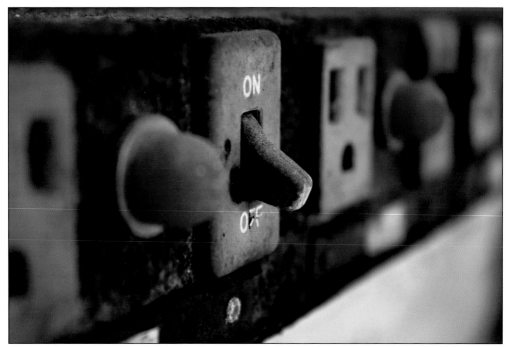

The majority of the school closed in 1991 due to a lack of funding, and the rest was shut down by 2002. By the end of 2012, only 45 buildings remained. The city tore down all but 10 structures by late 2012, many of which were only charred remnants due to several cases of arson.

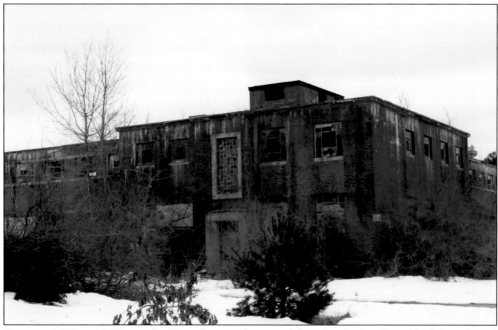

Between 2009 and 2013, a rash of fires destroyed many of the school's abandoned buildings. Local teens were arrested and arraigned in Taunton District Court, accused of setting fire to several of the buildings on campus. The local news outlets reported that a security officer called in about a fire at the two-story structure known as House No. 32.

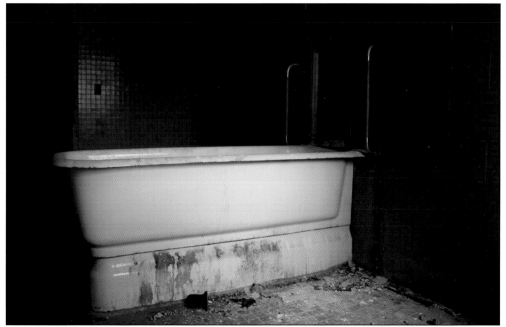

In addition to fires, other forms of vandalism plagued the former school campus. Concern for the safety of the town's residents eventually led to the buildings being torn down. Unlike many other such facilities in the state, much of the land has since been developed.

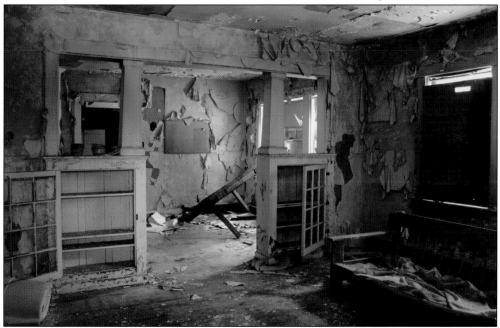

According to 1999's groundbreaking *Mental Health: A Report of the Surgeon General,* "In the 1950s, the public viewed mental illness as a stigmatized condition and displayed an unscientific understanding of mental illness. Survey respondents typically were not able to identify individuals as 'mentally ill' when presented with vignettes of individuals who would have been said to be mentally ill according to the professional standards of the day."

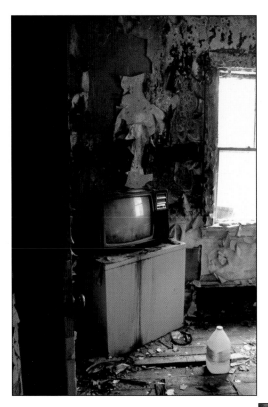

The report continues, "The public was not particularly skilled at distinguishing mental illness from ordinary unhappiness and worry and tended to see only extreme forms of behavior—namely psychosis—as mental illness. Mental illness carried great social stigma, especially linked with fear of unpredictable and violent behavior."

On the northwest portion of the former school property lies the Myles Standish Industrial Park, which is said to be the largest industrial park in the Northeast. Dozens of buildings litter the site, serving as the headquarters for many national and regional companies. The original 10 miles of low-speed track have been reduced to a single spur leading into the business park. This calendar was found in the recreation hall.

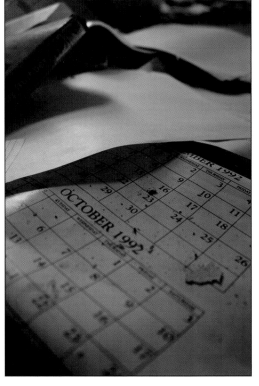

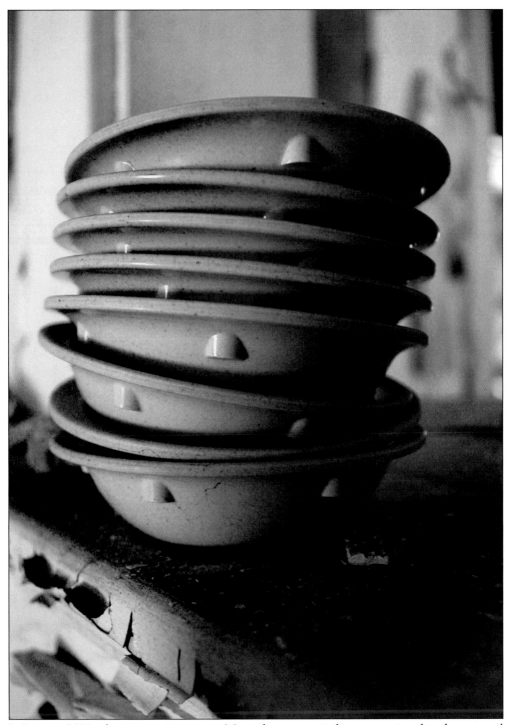

In January 2014, television stations across Massachusetts carried a story stating that the personal medical records of former patients and students had been left behind when the school closed. In the aftermath, the state ordered the clean-up and removal of these records, but urban explorers have reportedly found them in other former state facilities as well.

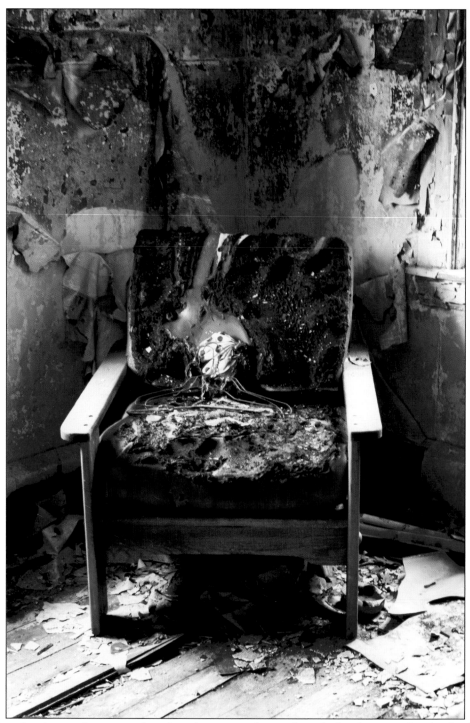

Though urban exploration within these former state hospitals and schools is considered unlawful trespass, many still break into these locations. State officials try to deter the practice by welding doors shut, boarding up the windows, surrounding the buildings with fence, and hiring security to keep trespassers out.

ABOUT THE AUTHORS

Tammy Rebello is a working photographer in central Massachusetts. Though her favorite photographic subjects are her four children, Tammy also enjoys documenting historical architecture and abandoned locations. She finds it important to document these locations so that current and future generations can understand the past and how it affected those who lived through those times.

Inspired by the strength and perseverance of her grandmother Anita, and the desire to make a better life for her family, she returned to the academic world. After four long years and many late nights, she earned a bachelor of arts degree in communication in the spring of 2015 from Worcester State University.

In her spare time, Tammy enjoys staying active with soccer, traveling, knocking things off of her bucket list, and most importantly spending time with her four children: Amanda, Emalee, Austin, and Errick—they are the loves of her life. More information on her photography can be found at facebook.com/TMRVisualArts or tammyrebello.wix.com/tmrvisualarts.

L.F. Blanchard was born and raised in Worcester, Massachusetts, where she is an artist and writer. While she's been writing most of her life, she only recently found her place in the art world. Her mother was a self-taught portrait artist and was one of L.F.'s biggest cheerleaders. When encouraged to take an art class, she stepped into that world and has not looked back. She enjoys the challenge of undertaking several different forms of art, but has a special affection for acrylics. Her artwork, photography, and information on upcoming shows and projects can be found at her website, LFBlanchard.com, or on her Facebook page of the same name.

LF holds two degrees: a bachelor of science in psychology and a bachelor of arts in visual and performing arts with a concentration in art. She is set to begin post-graduate classes in the fall, pursuing a master of arts degree in art therapy. She has a long history as a peer counselor and has spent several decades teaching personal safety and self-defense. On her off-days, she enjoys traveling around the country, with special interest in the beautiful national parks system and anything that gets her close to nature.

To find information about special events, book signings, and future projects, the authors can be found at facebook.com/Abandonedne or contacted by email at abandonedma@yahoo.com

DISCOVER THOUSANDS OF LOCAL HISTORY BOOKS
FEATURING MILLIONS OF VINTAGE IMAGES

Arcadia Publishing, the leading local history publisher in the United States, is committed to making history accessible and meaningful through publishing books that celebrate and preserve the heritage of America's people and places.

Find more books like this at
www.arcadiapublishing.com

Search for your hometown history, your old stomping grounds, and even your favorite sports team.